fROM tHE iNSIDE oUT

EIGHT CONTEMPORARY ARTISTS

ELEANOR ANTIN CHRISTIAN BOLTANSKI CLEGG & GUTTMANN
MOSHE GERSHUNI ILYA KABAKOV NANCY SPERO
BARBARA STEINMAN LAWRENCE WEINER

fROM tHE iNSIDE OUt

EIGHT CONTEMPORARY ARTISTS

ORGANIZED BY SUSAN TUMARKIN GOODMAN
ESSAY BY ARTHUR C. DANTO

THE
JEWISH
MUSEUM

.

1109 Fifth Avenue

New York, NY 10128

This catalogue has been published in conjunction with the exhibition
From the Inside Out: Eight Contemporary Artists,
June 13 - November 14, 1993,
organized by The Jewish Museum, New York.

AT&T is the corporate sponsor of
From the Inside Out: Eight Contemporary Artists.

Major funding for the exhibition was provided by
the National Endowment for the Arts, a federal agency,
the Family and Estate of Esther Hoffman Beller,
The Morris S. and Florence H. Bender Foundation.
Additional support has been received from
the Joseph Alexander Foundation,
The Judy and Michael Steinhardt Foundation,
Andrea M. Bronfman and the Government of Canada.

Exhibition Staff
Susan Tumarkin Goodman
Curator

Julie Reiss
Assistant Curator

Artel Exhibitions, Inc
Exhibition Design

HHA design, Hannah Alderfer
Catalogue Design

Catalogue printed by
Fleetwood Litho NY

CONTENTS

FOREWORD

The Jewish Museum's move from its original home in the library of The Jewish Theological Seminary of America to the Warburg house on Fifth Avenue and 92nd Street in 1947 provided an opportunity to greatly expand the exhibition program. At the time of the move, the Seminary's chancellor, Dr. Louis Finkelstein, encouraged the participation of contemporary artists who "expressed the traditions and aspirations of the Jewish people." When the Albert and Vera List building was added more than a decade later, the commitment to showing contemporary art was reinforced and the exhibition program developed to include avant-garde works which were virtually unexhibited in other museum settings at the time.

The exigencies which influence the history of that amorphous entity known as art world are complicated, having as much to do with economic and social issues as with the imagination, vision, and personality of artists, museum directors, curators, dealers, and collectors. The Jewish Museum's own programming of contemporary art has been made even more complex by its mission to, in effect, define Jewish culture—a mission that became primary in the late 1960s as more and more venues for showing contemporary art opened in New York. Today the Museum remains an institution where Jewish culture is the focus of all exhibiting, publishing, and educational programs. Contemporary art nevertheless continues to be an essential element in these programs: although universal in concept, it can also be an effective and direct means of revealing ideas critical to the experience of Jewish people.

From the Inside Out: Eight Contemporary Artists opens on the occasion of the third major expansion of The Jewish Museum in its eighty-nine year history. With a greater amount of gallery space, added public amenities, and improved facilities for storage and conservation, the Museum's ability to embrace the full scope of Jewish culture, from its Ancient Near Eastern roots through its evolution over four thousand years, has dramatically increased. This opening exhibition contains works by living artists whose art reflects conceptual, minimal, and metaphoric means of expression. The issues embedded in these works, however, are both of the moment and timeless. They express the experience of a people whose collective identity resides in an internalized memory and history that spans the globe, and in a religion grounded in a text that is constantly being reinterpreted. The discursive, disputatious, self-critical, humorous, observant, and critical aspects of Jewishness—all are treated in the works in this exhibition. For some of the artists, Jewish ritual forms the narrative structure of the work; for others, memory and the Holocaust are resonant themes. Evident as well are references to Jewish text, Yiddish culture, and anti-Semitism. By stretching the boundaries of art in their work, these eight artists stimulate new ways of thinking about and perceiving both the subject of their work and the world at large.

Many thanks to Curator Susan Tumarkin Goodman for her insightful and creative work in selecting the artists and contributing to this catalogue. The entire curatorial staff and the Board Exhibition Committee, chaired by Trustee Stuart Silver, have constantly championed contemporary art in the context of The Jewish Museum and created new and interesting ideas for exhibitions. I am also indebted to our very supportive donors, whose own vision of the power of art greatly helped this project reach fruition. At the time this catalogue went to press, the AT&T Foundation, the National Endowment for the Arts, the Family and Estate of Esther Hoffman Beller, The Morris S. and Florence H. Bender Foundation, the Joseph Alexander Foundation, The Judy and Michael Steinhardt Foundation, Andrea Bronfman, and the Government of Canada were among the contributors whose generosity is most appreciated. My deep thanks to all who have participated in this endeavor, whether through moral, financial, or professional support.

JOAN ROSENBAUM DIRECTOR

LENDERS TO THE EXHIBITION

Josh Baer Gallery, New York

Galerie René Blouin, Montreal

Canada Council Art Bank, Ottawa

Ronald Feldman Fine Arts, New York

Givon Art Gallery, Ltd, Tel Aviv

Marian Goodman Gallery, New York

Peter H. Schweitzer, New York

ACKNOWLEDGMENTS

Neither this exhibition nor its catalogue could have been realized without invaluable help from colleagues and friends. My deepest appreciation to the entire staff of The Jewish Museum who gave of its expertise and talent in the organization and coordination of the exhibition. Special thanks to Assistant Curator Julie Reiss, who participated in every phase of the planning and research and oversaw the project with dedication; to Dennis Szakacs, Development Associate, for his enthusiastic support and creative grant writing, which helped us achieve this project; and to Exhibitions Assistant Penny Liebman, who graciously carried out innumerable administrative tasks. I am grateful to Anne Scher, Director of Public Relations, for her efforts on behalf of this exhibition. Al Lazarte, Director of Operations, Geri Thomas, Administrator of Collections, and Susan Palamara, Registrar, skillfully coordinated the installation, and interns Melissa Ann Robbins and Ann Vollmann Bible assisted in the catalogue preparation.

I am indebted to Arthur C. Danto, whose essay illuminates The Jewish Museum's program, history, and involvement with contemporary art; to Sheila Schwartz for her sensitive editorial advice; to Hannah Alderfer for her creative and effective catalogue design; and to Paul Hunter for his invaluable consultation and patience in every aspect of the exhibition design.

The assistance of the following individuals was essential in assembling the art in the exhibition and the information in the catalogue: Betsy Kaufman at Lawrence Weiner's studio; Martina Batan at Ronald Feldman Fine Arts; Holly Hood Hughes at Jay Gorney Modern Art; René Blouin and Anne Delaney at Galerie René Blouin; Noemi Givon; Marian Goodman and Jill Sussman at Marian Goodman Gallery; Halley K. Harrisburg, formerly of Josh Baer Gallery; Emilia Kanevsky; the staff of the Reference Library of The Jewish Theological Seminary; and Maureen Fox, Sheila Friedland, Ilsa Glazer, Lynn Gumpert, Hilary Lieberman, Vivian Mann, Judy Siegel, Barbara Treitel, and Sharon Wolfe.

Joan Rosenbaum, Director, has worked with great dedication in promoting a contemporary arts program within The Jewish Museum; and Ward Mintz, Assistant Director, has supported and creatively supervised the complex development of this entire exhibition project. I am grateful to them both.

My final debt of gratitude is to the artists for lending or creating works and for their fruitful dialogue throughout the preparation of the exhibition.

S . T . G .

1947

Inaugural Exhibition

1948

Mordecai Ardon-Bronstein

Ben-Zion

1949

Elias Newman

Jankel Adler

Abraham Walkowitz

1950

Arnold Friedman

Leon Garland

Rabbi Abraham J. Shapira

1951

Lesser Ury

1952

Ben-Zion

Arthur Szyk

A. Raymond Katz

1953

Ismar David

Chaim Gross

Max Band

1956

Nahum Tschacbasov

Max Weber

Hilda Katz &
 Yehudith Sobel

Yehoshua Kovarsky

1957

Artists of the New York
 School: Second
 Generation

*Brodie, E. de Kooning,
De Niro, Follett, Forst,
Frankenthaler,
Goodnough, Hartigan,*

*Jocelyn, Johns, Johnson,
Kahn, Kaprow, Leslie,
Mitchell, Muller, Pasilis,
Rauschenberg, Resnick,
Sawin, Segal, Shapiro,
Solomon*

Anna Walinska

Adolph Gottlieb

1958

Arthur Kaufmann

Zvi Gali

Alice G. Gutmann

Nathaniel J. Jacobson

Gertrud & Otto Natzler

James N. Rosenberg

1959

Frances Manacher

Contemporary Jewish
 Artists from the
 Permanent Collection

*Blum, Castel, Gali, Gross,
Harkavy, Kovarsky,
Katustin, Lipchitz,
Litvinovski, Manacher,
Michelson, Millman,
Mittleman, Rubin,
Schneider, Seligman,
Tschacbasov, Walkowitz*

Ben-Zion

Nathan Rapoport

Kitty Brandfield

1960

Helen Frankenthaler

Calvin Albert

Hans Rawinsky

Elsie Orfuss

1961

Peter Lipman-Wulf

Shalom of Safed

Irving Kriesberg

1963

Holland: The New
 Generation

*Benner, van Bohemen,
Couzijn, Defesche,
Diederen, Frankot,
Lataster, Lucebert, Mooij,
Romijn, Sierhuis,
van Soest, Stekelenburg,
Visser, Volten,
Wagemaker*

Robert Rauschenberg
Toward a New
 Abstraction

*Brach, Held, Kelly, Louis,
Noland, Ortman, Parker,
Schapiro, F. Stella*

Black and White

*Motherwell, Newman,
Rauschenberg*

1964

Jasper Johns

Arshile Gorky

One Hundred
 Contemporary Prints

Recent American
 Sculpture

*Agostini, Bontecou,
Chamberlain, di Suvero,
Segal, Stankiewicz,
Sugarman*

Giora Novak

Art Israel: 26 Painters
 and Sculptors

*Agam, Aïka, Ardon,
Arikha, Bezem, Castel,
Danziger, Fima, M.
Gross, Haber, Kosso,
Krize, Lan-Bar, Lavie,
Mairovich, Nikel, Okashi,
Orion, Shemi, Stematsky,
Streichman, Tamir, Ticho,
Tumarkin, Y. Wexler,
Zaritsky*

1965

Richard Diebenkorn

Kenneth Noland

Dorothy Dehner

Venice Biennale, 1964

Ben Benn

Louise Nevelson

Pierre Alechinsky

Projects in Prints

James Rosenquist

Larry Rivers

2 Kinetic Sculptors

Schoffer, Tinguely

1966

Philip Guston

Environmental Paintings
 and Constructions

*Dine, Johns, Oldenburg,
Rauschenberg, Rivers,
Rosenquist, Segal,
Wesselmann*

Larry Rivers

Primary Structures:
 Younger American and
 British Sculptors

*Andre, Annesley,
Artschwager, Bell,
Bladen, Bolus, Caro,
de Lap, de Maria, Doyle,
Flavin, Forakis, Frazier,
Gerowitz, Gorski, Gray,
Grosvenor, Hall, Heubler,
Judd, Kelly, King, Kipp,
Laing, Lewitt, McCracken,
Matkovic, Morris, Myers,
Phillips, Pinchbeck,
Romano, Scott, A. Smith,
Smithson, Todd, Truitt,
Tucker, Van Buren,
von Schlegell, I. Witkin,
Woodham*

Alexander Liberman

Victor-Betelgeuse

Vaserely

Howard Kanovitz

Lee Bontecou

Ad Reinhardt

1967

Yves Klein

Large Scale American
 Paintings

*Bishop, Bluhm, Briggs,
Budd, Cavallon, Davis,
Dzubas, Frankenthaler,
Georges, Goodnough,
Held, Jensen, Katz, Kelly,
Krasner, Martin, Mitchell,
Olitski, Parker, Porter,
Resnick, Twombly,
Youngerman*

1968

Suites: Recent Prints

Gene Davis, Robert Irwin,
 Richard Smith

Passover in
 Contemporary Art

Young Italians

*Adami, Alviani,
Bonalumi, Castellani,
Ceroli, Grisi, Kounellis,
Lombardo,
Lo Savio, Mambor,
Pascali, Pistoletto*

Recent Italian Painting &
 Sculpture

*Accardi, Baj, Burri,
Capogrossi, Cascella,
Colla, Consagra,*

*Dorazio, Fontana,
Novelli, Perilli,
A. Pomodoro,
G. Pomodoro, Rotella,
Scialoja*

Wallace Berman

Robert Whitman

1969

European Painters Today

*Antes, Appel, Arman,
Bacon, Bury, Caulfield,
Dado, Dekkers,
del Pezzo, Denny,
Dewasne, Dorazio,
Fahlström, Fontana,
Geiger, Hantai, Hockney,
Hoyland, Hundertwasser,
Jacquet, Kitaj, Klapheck,
Klein, Leissler, Mack,
Magritte, Malaval,
Manders, Matta,
Messagier, Monory,
Piene, Pistoletto,
Rancillac, Raynaud,
Raysse, Requichot, Riley,
Schumacher, R. Smith,
Soto, Soulages, Stroud,
Struycken, Sugai, Tàpies,
Uecker, van Amen,
Vasarely, Walker*

Keiji Usami

Philip King, Brigitte
 Denninghof-Meir,
 George Karl Pfahler

Derrick Woodham

A Plastic Presence

*Ajay, Alberty, Alexander,
Amino, Artschwager,
Ballaine, Bassler, Baxter,
Bean, Beasley, Bennett,
Bieler, Black, Clancy,
Eversley, Gallo,
C. Gianakos, S. Gianakos,
Hesse, W. F. Jones,
Kauffman, Kolisnyk,
Krebs, Lamis, Levine,
Levinson, McGowin,
Nevelson, O'Neill,
O'Shea, Paris, Pashgian,
Pauley, Rabkin, Randell,
Redinger, Richardson,
Shipley, Simons, Stone,
Strick, Taylor, Valentine,
Van Buren, Viner,
Weinrib, S.L. Williams,
Zammitt, Zelenak*

Anna Ticho

1970
Dan Flavin
Beautiful Painting and
 Sculpture
Berthot, Bhavsar,
Quaytman, Sorce
Using Walls (Outdoors)
Crum, Daphnis,
D'Arcangelo, Wiegand
Using Walls (Indoors)
Artschwager, Bochner,
Bollinger, Buren, Diao,
Gourfain, Lewitt,
Morris/Kauffman,
Rothblatt, Ryman, Tuttle,
Weiner, Yrisarry, Zucker
Software Information
 Technology: Its New
 Meaning for Art
Acconci, D. Antin,
The Architecture Machine
Group, M.I.T, Baldessari,
Barry, Bradner, Burgy,
Conly, Denes, Enzmann,
Fernbach-Flarsheim,
Giorno Poetry Systems,
J. Goodyear, Haacke,
Huebler, Kaprow, Kosuth,
L. Levine, Nelson, J. Nolan,
R.E.S.I.S.T.O.R.S., Razdow,
Schley, Sheridan,
Vandouris, Victoria,
Weiner, Woodman
Gonzalo Fonseca
Julia Pearl

1971
Chuck Ginnever
Eugene W. Smith

1972
Anatole Kaplan
Boris Penson
Fima
Avraham Ofek

1973
Nora & Naomi
Shraga Weil
Luise Kaish

1974
Leonard Baskin
Igael Tumarkin

1975
Yaacov Agam
Pinhas Shaar

1976
Ludwig Wolpert
Ben Shahn

1977
Tony Rosenthal
Chaim Gross

1978
Jack Levine

1979
Erich Brauer
Sarah Swenson
David Aronson
Seymour Lipton

1980
Andy Warhol
Dan Reisinger

1981
Artists of Israel:
 1920-1980
Agam, Ardon, Arikha,
Aroch, Bak, Bergner,
Castel, Cohen Gan,
Danziger, Efrat, M. Gross,
Janco, Kadishman,
Krakauer, Kupferman,
Lavie, Levanon, Lifshitz,
Mairovich, Neustein,
Nikel, Paldi, Rubin,
Schwartz, M. Shemi, Y.
Shemi, Simon, Steinhardt,
Stematsky, Streichman,
Tagger, Ticho, Tumarkin,
A. Uri, Weinfeld, Zaritsky
Maurice Golubov
Anatole Kaplan
Beth Ames Swartz

1982
Dina Dar
June Wayne
Jewish Themes/
 Contemporary
 American Artists
E. Altman, Breverman,
M. Cohen, Gavin, Kirili,
Kitaj, Klement, Komar
and Melamid, Natkin,
Petlin, Reice, Schwalb,
Shaw, Shechter, Snider,
Weisel, J. Witkin

1983
Frank Stella
George Segal
Judy Goldhill
Jack Kugelmass
Anna Ticho

1984
Larry Rivers

1985
Menashe Kadishman
One Little Goat:
 Two Artists El Lissitzky,
 Frank Stella

1986
Moshe Zabari
Jewish Themes/
 Contemporary
 American Artists II
Baron, David, Fishman,
Flack, Goldyne, Gray,
Hafftka, Imber, Kahn,
Kirschenbaum, Lerman,
Marcus, S. Miller, Rand,
Ripps, Shorr, Silverman,
Sperry, Spiegelman,
Thompson, Ukeles,
Waitzkin, S. Weber,
Zarbin-Byrne

1987
Lenke Rothman

1988
Stuart Klipper
Time and Memory:
 Video Art and Identity
Downey, B. Friedman,
R. Friedman, Gorewitz,
Korot, Kubota, Marton,
Paik, Rosenthal,
Weinbren

1989
In the Shadow of
 Conflict: Israeli Art,
 1980-1989
Ben-David, Cohen Gan,
Garbuz, Gershuni,
Geva, Gitlin, Kadishman,
Klasmer, Kupferman,
Mezah, Mizrachi,
Moriah, Muller,
Neustein, Reeb,
Tumarkin, Ullman, Uri

1990
Wijnanda Deroo
Helène Hourmat
Eli Content
Ilene Segalove

S C U L P T U R E
C O U R T

1966
Kosso Eloul

1967
Chryssa
Jacques Lipchitz
Robert Murray
Herbert Ferber,
 Ibram Lassaw

1968
Wilfred Zogbaum,
 Beverly Pepper
Calder
Hadzi
Paolizzi

1969
Les Levine,
 Charles O. Perry
Kip Coburn
Duayne Hatchett
Ted Bieler

1970
Donald Judd
Menashe Kadishman
Antoni Milkowski

1971
Elbert Weinberg

1972
Yaacov Agam

1973
Danziger
Bernard Rosenthal
Yehiel Shemi

1974
Nathan Rapoport
Bernard Reder
Igael Tumarkin
Stuart Silver

1975
Dina Recanati
Chaim Gross
Luise Kaish

1976
Michael Gross
Robert Indiana

1977
Chaim Gross
Jacques Lipchitz
Kosso Eloul

1978
Herbert Ferber
Boaz Vaadia

1979
Raquel Rabinovich

1980
Louise Kaish
Elbert Weinberg

1982
Alain Kirili

1983
Anthony Caro

1984
Dina Recanati

1985
Menashe Kadishman

1986
Buky Schwartz
Stacey Spiegel
Ilan Averbuch

1987
Zigi Ben-Haim
Igael Tumarkin

1988
Seymour Lipton
Allan Wexler
Boaz Vaadia

1989
Ilan Averbuch

1990
Robert Ressler
Osvaldo Romberg

ARTHUR C. DANTO

POSTMODERN ART CONCRETE SELVES

THE MODEL OF THE JEWISH MUSEUM

The art historian Erwin Panofsky claimed to perceive certain structural analogies between the art of a given period and that period's philosophy, almost as if there were some single unifying spirit which expressed itself in parallel ways in these two symbolic modes. He believed, for example, that the Renaissance discovery of perspective was not merely the truth of how objects recede in space from a fixed point of view, but was as well the aesthetic counterpart of certain Renaissance understandings of the nature of human knowledge. He similarly believed that the altogether different spatial conventions of Byzantine art expressed "the metaphysics of light of Pagan and Christian Neoplatonism." It was not that the artists and philosophers of a given historical moment were especially in touch with one another, or studied one another's ideas, or belonged to some single intellectual community, but rather that there always exists some underlying principle made visible and objective in the philosophy as well as the art of that moment. Perspective at once gave Renaissance artists a way of convincingly representing the world, and a way of expressing, in the deepest possible way, the culture to which they belonged. Panofsky gave the name *iconology* to the study of these undeniable resonances between the art and the philosophy that together define the internal spirit of a period.

It is striking how closely contemporary and recent turns in art and philosophy appear to confirm Panofsky's speculation, and it will be useful to assess the inaugural exhibition of the remodeled and, in some measure, the rededicated and redefined Jewish Museum against this background. Perhaps as recently as twenty years ago there was a certain consensus in moral philosophy and in the philosophy of art that ethical and aesthetic values were universal, invariant to all times and places; the task of the good society was to embody universal principles of justice just as the task of good art was to embody principles of beauty valid for all human beings. It was, on either side, very much as if individuals

were themselves deeply the same, throughout all periods of history and irrespective of cultural location, so that their particular concrete identity, in terms of race, of gender, of historical situation and political placement, did not belong to their essence as human. The self, so to speak, was an almost mathematical point, logically situated outside time and space and circumstance, which were as so many inessential garments, to be cast away in the greater consideration of what is right and just, what is true and false, what is beautiful and what is not. One's Jewishness, for example, would be a matter of external accident, something one happens to have, but which, without losing one's essential identity, could be put on or taken off. The philosopher John Rawls, in a famous and profound work, *A Theory of Justice*, imagined what it would be like were human beings separated by an impenetrable Veil of Ignorance from the society in which they lived, and were then asked rationally to choose the principles of justice which were to define that society. Rawls seems confident that they would all pretty much hit on the same liberal principles, giving themselves the best possible deal if, when the Veil was removed, they turned out to be the least advantaged members of the society. But the presupposition was that humans, in making their choices, are all alike, what a recent critic of Rawls calls "ciphers," all of whom will spontaneously choose the same universal principles. But that means that the roles they finally assume, when placed in the imagined society, are external to what Rawls allows as inherently belonging to human beings: their ability to make certain rational decisions—their *reason.*

This view of what it is to be human originates in the philosophy of Kant, as does its parallel conception of art. Kant claimed that moral principles apply to humans only insofar as we are rational beings, and hence capable of acting in conformity with those principles, which are as universal as the laws of nature. Indeed, Kant's celebrated Categorical Imperative directs us to act only on those "maxims," as he terms them, which we are prepared to universalize, and hence to will as binding upon all beings like ourselves. And a moral principle in Kant has no validity whatever if it is not universal. There is, then, no sense in Kant of history making any difference, or culture, or religion, or the deep circumstances that in fact affect us as profoundly as earth and light affect the far less complex composition of wine. And in his thoughts about art, Kant insisted that the task of art is to induce pleasure of a kind we call beautiful only because we believe that the pleasure is universal: we judge aesthetically for all rational beings. "The subjective principle in judging the beautiful," he wrote, "is represented as universal." Hence the beautiful, in his philosophy, is "the symbol of what is morally good" in that "it gives pleasure with a claim for the agreement of everyone" (*Critique of Judgment*, §59). The idea that the principles of moral life, as well as the principle of aesthetic judgment and of artistic creation, are deeply uniform expresses what we may call the Kantian consensus in the philosophy of good societies and good art. The recent turn in ethics and in art marks the disintegration of this consensus.

I shall make no effort in this essay to speak of the criticisms of the Kant-Rawls philosophy of the good community. But its basis lies in a very different conception of what it is to be a self than either of them allows. A self is not an abstract point of pure reason, the same in all times and climes and cultures. The self, rather, is the concrete product of many forces and causes which mark it totally: it is in particular the embodiment of its culture, its gender, its traditions, its race; and these are not matters to be thought away in asking what the good life for human beings is, to which the only satisfactory answer is some universal principle. And so an adequate theory of morality must take into account the concreteness of concrete selves in their immediate societies. Whatever the outcome of such an inquiry, our ethics must acknowledge, must begin with, the multiplicity of our identities and what differentiates us as real. It is not surprising to find a corresponding particularity in contemporary views on art. Art is

multiple in its sources and diverse in its satisfactions, and, save at the most abstract levels of philosophical discourse, there can be no one thing that art is and must be. Often, theorists of art identified what was in truth but a momentary style with the philosophical essence of art, and insisted that unless works of art attained to this essence, they had no justification. The view today is that there is no such essence, at least none that is to be identified with what is after all but a style. It is therefore not surprising, if there is anything to Panofsky's views at all, that in that period when Rawls was hammering out his philosophy—the late 1950s and early 1960s—the philosophy of art, and especially of the visual arts, was essentialistic, universalist, and historically complacent. The vehicle of this universality was characteristically painting and, to a far lesser degree, sculpture. The endeavor was to identify a genre of painting that was pure, and which hence expressed the deepest and most final truths of art. It would be abstract, the pleasure it might afford would be almost intellectual, and in its platonic absoluteness it would stand outside history. It made no concessions to the special conditions of its viewers. Their experiences must ultimately be all alike, exactly the similarity entailed in Kant's ascription of beauty. It made no difference whether the viewer was male or female, white or black, Jew or Gentile, American or European.

A chief proponent of this puristic vision of the work of art was the uncompromising New York artist Ad Reinhardt, and it is worth noting that the first major exhibition of Reinhardt's work was mounted at the Jewish Museum in New York in 1966. The Jewish Museum in those years was the main venue for the most advanced visual art of the era, an exhibition space hospitable to experimental art far more consistently than any museum in the city, and especially more so than the Museum of Modern Art, which had settled for an almost canonical modernism, and the Whitney Museum of American Art, which only sporadically presented art of what has come to be called the cutting edge. For a period

of some years, the Jewish Museum was the place to see the art that was self-consciously advancing the theoretical consciousness of what art is and, specifically, the art that was then beginning to call into question the premises of the tacitly Kantian aesthetics which defined the production and appreciation of painting in the high phase of Abstract Expressionism. If one saw the work of Reinhardt and Philip Guston (when Guston was still a lyrical abstractionist and had not yet gone into the charged political imagery which marked his art at the end), one could also see the work of Jasper Johns and of Robert Rauschenberg, who were beginning to dismantle the Kantian aesthetic in ways no one could foresee.

It must have been perceived as something of an anomaly that the living edge of art history was being made visible in an institution identified as the Jewish Museum, for there was nothing particularly Jewish about the art, and indeed, as we saw, it was inconsistent with the official aesthetics of the mid-sixties to figure religious or racial identity into the determination of art as good. There was, nevertheless, some interest on the part of advanced theorists, who took a natural pride in the fact that the most vanguard art was *American*—that America had broken through and become the artistic capital of the world—and who discussed whether there was some special Americanness in the art being made.

In my own case, so far as I thought about the question of modern art and Jewish identity, I thought of a propensity of Jews to associate themselves, if not as practitioners then as patrons, with the most advanced intellectual and artistic activities of the time—as patrons of the human spirit in its culturally highest attainments. In fact I took a certain pride in that association, and it seemed to me that the Jewishness of the Jewish Museum could not more appropriately express itself than in sponsoring this extremely adventurous art, whatever the identity of those who made it. The twentieth century had seen the emergence of a number of Jewish artists of world-class achievement, but certainly, in my view at

least, their Jewishness had nothing to do with this achievement, anymore than the Spanishness of Picasso or the Frenchness of Matisse or the Russianness of Malevich had to do with the greatness of their art. It was a fact, but an external fact, that they had national or ethnic identities. I took it for granted that Jews should excel in the arts, once the barriers, internal and external to their tradition, were removed, much as it seemed to me altogether expected that Jews would excel as physicists or philosophers once it became possible for them to gain entry to academic study. And for much the same reason that one would have been reluctant to ascribe a particular Jewish content to the work of the great Jewish physicists, or to that of the major Jewish philosophers, many of whom had been among my teachers, one did not see in the art of Jewish artists anything one cared to identify as Jewish, and certainly not when it came to explaining the goodness of their art.

Whatever the case, this ascription of an internal connection between patronage and cultural excellence as itself a Jewish trait could have been buttressed, had one cast about for historical evidence, by the history of the Warburg family itself, which had after all, in 1944, given its marvelous mansion to the Jewish Museum. This was especially true of "Eddie" Warburg, who had been among the earliest American patrons of modernism, in painting, sculpture, architecture, and in ballet. His own precocious acquisitions, among them an outstanding Picasso of the Blue Period, had been installed in the house when it was still a family home. And it is worth pointing out that Edward Warburg's uncle, the scholar and art historian Aby Warburg, was the founder of the Warburg Institute and Library, to which Erwin Panofsky belonged. Panofsky's concept of iconology, which developed out of his 1927 work on perspective (a publication of the Warburg Institute), was intended as a contribution to the philosophy of symbolic forms, a theory advanced by another of the Warburg scholars, Ernst Cassirer. Cassirer's thesis was in fact a criticism of the universalist theory of human nature assumed by

Kant, which I have taken as the background theme of this essay. Against the Kantian thesis that the human mind is everywhere and always the same, Cassirer, and after him Panofsky, insisted that experience is processed through a number of "symbolic forms," which include language, myth, religion, art, and philosophy, and that these very much differ from cultural moment to cultural moment and from one historical location to another. The Jewish Museum during the sixties, however, tacitly endorsed the Kantian aesthetic in what one might think of as its front portion; the "Americanness" of the art exhibited was in effect the universalizability principle that expressed the advanced attitude toward art and social values at the time. It was the neglected back portion of the Museum, which housed objects steeped in explicit Jewishness, that came closest to embodying the philosophy of symbolic forms, a philosophy with which the members of the Warburg Institute sought to replace Kantian psychology in order to get something closer to the realities of human mentality.

In the later sixties, this more particularistic philosophy of the Warburg patrimony was indirectly embraced by the Museum's trustees, who turned away from the universalizing temperament of contemporary art and insisted that Museum exhibitions henceforth reflect the institution's Jewishness. The Warburg family, through the activities of Edward Warburg and the philosophical heritage of the Warburg Institute itself, was connected with both the particularistic and universalizing philosophical trends. By deciding to abandon the cultural universalism of art and to shelter instead the palpable remnants of what everyone conceded was a vanishing if not vanished Jewish culture, the Jewish Museum embodied the tension between Kantian philosophy and the more historicizing philosophy of symbolic forms.

The decision to retreat from the frontier of avant-garde culture was perceived by many at the time, myself included, as the willed destruction of a vital institution. Indeed, given the justification for the

showing of contemporary art by a *Jewish* museum, that is, the connection between high cultural patronage and Jewishness, the decision seemed to betray part of the traditional definition of Jewishness. The arguments made at the time—that there were by then many alternative spaces in which advanced art could be seen, making it less and less necessary for the Jewish Museum to play a mediating role between an art not especially Jewish and an audience not especially Jewish—seemed beside the point. The Jewish Museum, after all, had not been doing something because no one else was, but had simply been doing what was expected of a Jewish museum. In the event, I dare say the decision was precocious in terms of the cultural particularism that was destined to overtake American culture—that was destined to overtake *world* culture—in the postmodern era. And who can say whether identification with the avant-garde was not an effort to submerge Jewish culture in some dissolutive universality? A form of aesthetic assimilationism?

Throughout the years of its cultural ascendancy, the Jewish Museum had housed a permanent collection of artifacts, representative of ritual and ceremonial practices of the Jewish people, shown in display cases like anthropological specimens. Younger Jews might conduct their parents through these exhibits, which often elicited memories of life in Europe: the spirit in these objects was released at such moments, like the genies captive in bottles in *The Arabian Nights*. But the response of younger Jews themselves was different. For them, the meaning of the Jewish Museum lay in the building's great display spaces with avant-garde art, and they did not find it aesthetically jarring that paintings which often renounced ornamentation were hung in rooms heavy with ornament, in the intricate Neogothic taste of the baronial American plutocracy. Unless the life of the ritual objects was released by the catalyst of a parent or an older relative from another culture, these objects were as distant as those on display at the American Museum of Natural History. The religion of

Japan, Zen in particular, seemed more relevant to contemporary art than one's "own" religion, which was simply something one happened by historical accident to have; it did not penetrate one's sense of being or self-image. There was no outflow from object to sensibility and soul since there was no inflow, from soul to vessel or manuscript, of meaning and spiritual proprietorship.

The immediate consequence of the decision to vacate as an avant-garde venue was that the Jewish Museum dropped off the A-list of aesthetic foci on the art world's cultural map. It became in part the specialized focus of scholars with a research agenda in Judaica and of those, always a significant number among the culturally avid in New York, who had an interest in the exotic, in the out-of-the-way, as exhibitions with Jewish content must appear in the cosmopolitan context. But it also—and this came to be of more and more importance—became a point of pilgrimage for those to whom it had begun to mean something that there was, in New York, a *Jewish* museum. For these visitors, the Jewish Museum was a required stop because it was specifically Jewish and a museum—whatever its content and whatever exhibition, of scholarly or aesthetic interest, might happen to be up at the moment. These people, as I have come to recognize, represent a by no means negligible constituency, and it merits a few paragraphs to explain why.

The prevailing concept of the museum in the 1960s—a concept largely formed in the course of the nineteenth century—held that it was a treasury of works of art of the highest quality and a resource for scholars interested in the history of art. Scholars excepted, one went to the museum to be in the presence of great works, an experience deemed educational in two ways. One learned, by visiting the galleries devoted to the various "schools," ordinarily organized chronologically, something of the history the school underwent in pursuit of its highest attainments. And from the

works that constituted these achievements, one also learned which conveyed, or were believed to convey, truths and values of the utmost benefit to those who absorbed them.

There was, however, another function of the museum, strongly emphasized in its early modern days, preeminently in the Louvre when it was the Musée Napoléon, but which had become fairly vestigial by mid-twentieth century. The Musée Napoléon had gathered, through conquest, the highest artistic products of the conquered nations, and these were displayed almost as trophies. The French citizenry entered the space of the museum in part to feel the power of their nation, not simply through French artistic achievements, but, in a political sense, through the palpable power represented by possession of the masterpieces of vanquished populations. The museum confirmed their sense of themselves as a nation. Moreover, the intention was to foster, through the museum experience, a sense of self-identity with their own political community. This experience was the *raison d'être* of the Musée Napoléon, and it was in part to make this experience possible for their own citizens that the Prussians and the British—ultimately Napoleon's victorious enemies—established their respective national galleries. The museum, in the early nineteenth century, became a kind of secular church, where the congregation affirmed and reaffirmed its identity. It became—and this is made manifest in the architecture of that era's museums—a temple on a hill. And although the intense nationalism the Musée Napoléon was calculated to instill abated over the decades, nations continued to treat their museums as living monuments to nationhood. The Rijksmuseum, for example, was built as a temple to the Dutch spirit, which expressed itself in the works of the great Dutch masters; and the Dutch clearly felt themselves in touch with their Dutchness when imbibing, through the eyes and feelings, the national essence distilled in *The Night Watch* which functioned as a kind of altarpiece.

A museum defined along these political lines inevitably divided the experience of visitors, depending upon whether they belonged to the group whose spirit was embodied by the museum and its content, or to the outsiders, whether tourists or aesthetes, to whom that spirit was in every sense external. The one group was strengthened in its Frenchness or its Dutchness by the art, the other had no such relationship to be strengthened. Of course, the externalist relationship to art became, over time, the prevailing one. For institutions such as the Museum of Modern Art in New York, the primary *raison d'être* of art was aesthetic and its essence formal; following this principle, considerations of identity inherent to the national museums of Europe could not be applied. But in truth this was the case with most American museums. There was nothing in its great holdings which bonded the Detroit Institute of Arts to natives of Michigan, and the Museum of Fine Arts in Boston was at best marginally associated with Bostonians. The Metropolitan Museum of Art was universalist, as was even the National Gallery in Washington, despite its name. The self-adopted function of the National Gallery, like that of most American museums, was the promotion of aesthetic cultivation and of scholarship in the arts. The Jewish Museum as an avant-garde venue was universalist in this spirit, even if its scholarly focus was more narrowly concentrated on collections of Judaica. For the modern art it showed was presented in the spirit of universalism which went with the Kantian consensus.

Kant actually helps make clear the difference between audiences, one universalist, the other approaching art in order to connect with a special community. In the *Critique of Judgment*, Kant argues that the experience of beauty excludes all components of what he calls *interest*. The pleasure elicited by objects perceived as beautiful is, in his words, "merely contemplative, and does not bring about an interest in the object." In fact, "every interest spoils the judgment of taste and takes from it its impartiality." He goes even

further: "Judgment so affected can lay no claim at all to a universal valid satisfaction." As we saw, the claim that something is beautiful entails, for Kant, the further claim that everyone in principle must find it so; accordingly, the idea of an admixture of interest is incompatible with the appreciation of beauty. Hence aesthetic judgment is in its nature *disinterested*. Kant's philosophy was formed before the era of nationalism which gave rise to the great museums, among other emblems, and it is clear that his idea of art is altogether different from that which underlies those museums. Their conception of art is very much one of interestedness, and is not at all universal. The art, like the museum, speaks in a special way to the group whose art and museum it is. To experience the art is, from the very start, to have an interest—not personal or individual, but the interest which has as its object the furtherance of the group to which one belongs. The art is there for the sake of that interest. From this perspective, the primary concern of art is not that it be beautiful; beauty is at best secondary. It follows that artistic experience is not aesthetic either: it is instead political and instrumental. The experience of the art is one avenue for entering into oneness with one's group. Needless to say, art made present to visitors internally related to it through interest need not be great art by universal criteria. It need only distill the same spirit they themselves possess, making possible the intended internal relationship. Of course, when the art is great, as with the Dutch masters, this redounds to the overall credit of the group which confirms itself through the masterworks.

It was in this spirit, then, that those who made the Jewish Museum a point of pilgrimage arrived, in increasing numbers, after it renounced its universalism and in some measure its aestheticism. They came in order to be in the presence of art that was Jewish because they themselves were Jewish. They were one with the Museum and its art. Their identity was reinforced when in the midst of that with which they were one.

The sixties was a period of intense museum construction in the United States. In the early years of the decade new museums were opening nearly every week, and many of our major architects' first commissions came with the invitation to design a museum. A good many of these museums reflected an interest in art that was itself the result of Americans having traveled abroad, or having taken courses in art history and art appreciation in colleges and universities—and of the growing sense that access to art was more and more woven into the conception of the good life. Corporations located in smaller urban centers contributed to the growth of museums as a way of providing cultural incentives for attracting executives. The museum, like the symphony orchestra, the ballet, the repertory theater, became a focus of community pride. But the premises of the art remained aesthetic and universalist: art was for everyone, and to be experienced in the same way by all. Docents everywhere talked about diagonals and concentricities, surface textures and phenomenological spaces.

Yet there was another kind of museum that came to have increasing importance under various political agendas in the United States and elsewhere. It was part of these agendas that constituencies have museums *of their own*, in which they, through the art of their membership, could celebrate their specialness—not just their identity but their difference from other groups. A case in point was the National Museum of Women in the Arts in Washington, D.C., a special building in which art by, for, and of women could be made accessible to the enhancement of gender pride. The museum of course was open to "others," specifically men. But the experience was in no sense disinterested. It was in no sense universal. It sometimes was claimed, by critics of either gender, that the work there was not always of the highest quality. Yet the criticism of quality belonged to a different conception of the museum, of art, of artistic expression, and artistic experience. It imposed an irrelevant conception of the ideal of the museum. To

insist that only the disinterested museum had validity as an institution was to beg the question.

The difference between the museum as focus of civic pride and the museum as the agency of disinterestedness is built into the history of the museum as an institution. It is not surprising that in the sixties the Jewish Museum, more than most American museums, incorporated both dimensions of the museum concept, not surprising that it should have been perceived as anomalous for this reason. It is extremely difficult to have a conception of art that is at once interested and disinterested, and it is wholly comprehensible that in the period in which the Jewish Museum changed direction, it defined itself as the kind of museum whose rationale, in part, is to tell members of its immediate constituency why they are members of it. And any number of museums which were initially scholarly museums underwent a parallel transformation, such as the Museum of the American Indian. In the course of the seventies and the eighties, the display cases of such museums, which originally housed objects of study—classified, labeled, and described—underwent a powerful metamorphosis. The change was from the presentation of objective data for the sake of knowledge to the creation of subjective opportunities for communion with the history of the viewer's own group. Visitors came now less for knowledge than for a kind of inspiration: not in the disinterested posture of archaeology, but in the interested posture of the adherent and the celebrant. The objects in the Jewish Museum condensed the history of Jews, and the exhibition that will be referred to in the reconstructed Jewish Museum as *Culture and Continuity: The Jewish Journey* will have inevitably different meanings for visitors depending upon their interests, which in turn depend upon their identities. The Museum in fact has two relationships with this exhibition. One is external to and contains it. In the other relationship it is part of the exhibition. The Jewish Museum itself stands in the two kinds of relationships to visitors that the objects in it must. It continues the history it displays.

It must be clear by this point that the same social and political forces which explain the reemergence of the museum of interest and identity explain as well the breakup of the Kantian universalist philosophy of good and right. It is exactly those factors which set the group apart in the image of itself shared by its members that theorists now insist must also belong to the concrete self shaped by the group. One does not confront society as a *tabula rasa*, an individual cleansed of the divisions of gender, race, culture, class, or ethnicity. So moral systems may be as various as the order of concrete selves that compose societies. Needless to say, this kind of pluralism does not come without costs. The extreme costs are the ethnic hatreds and resentments which rend so many societies today into bitter factions. And there are other, less dramatic costs as well, such as the partitioning of curricula into different kinds of "studies"—women's studies, black studies, working-class studies, Jewish studies, Chicano studies—where education continues the work of the museum in reinforcing identities and bringing them more and more into consciousness. All these separate identities reinforce boundaries that the Kantian ethic sought to overcome through its insistence on the universality of morally justified precepts.

The failure of the Kantian ethic, however, is not our problem here. It remains for us to describe how the forces that gave rise to the museum of interest and identity were able to take advantage of certain changes internal to the history of art, which in turn made possible a kind of art making along pluralistic lines. This involves the breakup of the other relevant part of the Kantian consensus, which makes beauty criterial for art and which excludes the ingredient of interestedness as not belonging to the experience of art in its purest state. By contrast, the pluralistic art in question is only secondarily assessed in aesthetic terms, and it is almost inconceivable without reference to particular interests. It is, needless to say, an art capable of dividing audi-

ences into those internally related to it and into outsiders to the spirit the art attempts to embody.

The history of Western art is spontaneously conceived of as the history of Western painting. It is a history like no other by virtue of having been, until late in the nineteenth century, the progressive attainment of representational adequacy. Even when *representational* adequacy receded as the goal of painting, the assumptions of progress remained, leaving participants in the institutions of art with a vocabulary of advance and breakthrough, stagnation and even decline: to be a painter was in effect to see oneself located in a history which demanded that one always carry the standard of artistic advance into the strenuous future. From the perspective of painting, accordingly, the decade of the seventies appears to have been less a period of art history—by then it had become almost common practice to think of the decade as an art historical period—than a gap between two periods, perhaps that of the Minimalism of the later sixties and the Expressionism of the 1980s, when it seemed to a great many in the art world that art history was again back on track. It *is* true that very little happened in *painting* in the seventies, but unless we narrowly identify art with painting, the decade was one of astonishing creativity, whose art history has as yet not been mapped, let alone understood.

In fact it began to seem a critical commonplace to claim that painting had come to an end in the seventies, that there was no further place for painting to go on the progressive path (and tacitly that there was no further point in painting). This itself requires a bit of perspective. The "death of painting" has, in the twentieth century, frequently been pronounced, usually as a corollary of some revolutionary agenda, in which the agency of art was to be enlisted in a social or political cause. And the seventies, a strenuously politicized period, was no exception. Painting was increasingly impugned as "patriarchal," as the vehicle of some kind of white male aesthetic which could not be applied, or could only be oppressively applied, to artists who were neither white nor

male and whose "language of forms," to use a phrase given currency by Linda Nochlin, might not finally be suitable for women in particular at all. It was inevitable that in a period in which art was *interested* that painting, as the vehicle par excellence of the *disinterested* apprehension of beauty or aesthetic form, should have come under polemical attack. In an earlier era, interestedness would doubtless have found its outlet in representational content, in the form of propaganda or at least of visual rhetoric. But in the era of abstraction, this would have meant a backward move; indeed Guston's cartoony political emblems were regarded as retrograde. Even artistic rebellion in the West takes on the appearance of art historical advance. So the agenda was unavoidable and clear: to make an art alternative to painting without reverting to modes of painting that art had superseded. The politically energized seventies were astonishingly fertile in hitting upon alternative forms of art making—body art, earth art, fabric art, performance art, video, installation, conceptual art, and beyond. As a beneficiary of this fertility, sculpture underwent a kind of renaissance merely because so many of the new forms required real space for their realization and thus seemed closer in genre to traditional sculpture than to traditional painting. Painting, then, heretofore the spear point of progress, was, in the seventies sent to the back ranks, where it perhaps remained and will remain. And of course the idea of beauty, so natural and appropriate in connection with painting, seemed less and less relevant to the new art being made, which was defined internally in terms of the interests of the artist and the intended audience.

Of the new forms, performance is in certain respects the easiest to grasp. In it, an immediacy of presence of the artist is assured, and hence an immediacy of confrontation between artist and audience in which both are in some way put at risk. The performance artist is not endeavoring to create beauty, but to achieve the transformation, possibly the explosive transformation, of consciousness. Performance is a genre to which women

have taken in great numbers, perhaps because the concept of consciousness-raising was a strategy of early feminism; and the performer will, to this end, do certain things to herself, use dangerous language, flaunt certain boundaries, enact certain gestures, which can, which perhaps must, put her audience on a precarious edge. In a way, performance connects with a very early form of art, in which the artist was a kind of priest or priestess whose actions were designed to obliterate the gap between performer and audience, and perhaps between members of the audience. Whatever the case, the Kantian ideal of contemplation does not go with performance. What instead goes with it is participation, a readiness to undergo change, a willingness not just to have had a certain experience but to have become a different person in consequence of the experience. Performance has lent itself naturally to political action. Through the transformation of consciousness the artist intends a transformed society.

A great deal of the art that came to take the place of painting in the seventies was, in its own way, critical of the institutions that had grown up around painting: the gallery, the collection, the marketplace, even the museum itself. And by contrast with the atemporality aspired to by art—the thing-of-beauty-is-a-joy-forever criterion of aesthetic goodness—the art of the seventies was often inherently ephemeral. Performance might result in modified consciousness, but the art work had a limited, at times very limited duration. It could not be collected, it could only be repeated. It could be funded, but not readily bought or sold. It is something of an irony, if not a tragedy, that the major funding agency in America—the National Endowment for the Arts— should have found itself being asked to fund an art that was bent precisely on the kind of moral and political action hardly imagined at the Endowment's beginning, in 1965, when the aesthetic imperative of art was taken as paradigmatic. I have elsewhere spoken of the "disturbational" ambitions of performance art, and this seems almost incoherent with the aims of art as construed

by the Endowment. It is hardly cause for wonder that the Endowment encountered such heavy weather in Congress: it was being asked to subsidize art often critical of the very fabric of the society for which Congress stood.

Installation art shares many of the features of performance, and it increasingly became the vehicle for artists with particular interests, for the pursuit of which the art was a means. It is in the first instance participatory rather than contemplative and subversive rather than gratificatory. Entering the installation, one is meant to emerge somewhat altered by the experience. In September 1992, an exhibition sponsored by the Museum of Contemporary Art in Chicago opened at the Chicago Armory—a form of architecture inevitably associated with artistic radicalism through the echoes set up with the notorious Armory Show of 1913 in New York. The title of the show, characteristic of installation art, was "Occupied Territory." The term "occupation" implies the vociferous outcome of armed struggle; that art should have taken over space heretofore devoted to military drill emblematizes what the art itself aspires to. Each of the nearly twenty pieces had an agenda: the AIDS crisis, the crisis of the environment, racism, and sexism being favored targets. These works are not just about AIDS or the environment, the way classroom projects would be. They are not there just to give information. They are there to *move minds*.

The constellation of installation pieces in the inaugural exhibition of the new stage of the Jewish Museum will be less diffuse and less trendy. But, in a general way, the works aim at the same goal: they may give information about aspects of what it means to be Jewish, but their intended force is not exhausted by the transmission of information. Or better: the content is less to be mastered than earned by participation, as the visitor lives through the experience of the installation and in this way grasps its meaning. As with all interested art, these pieces will of necessity divide spectators: those not Jewish will not be moved to reflect on the meaning of their Jewishness. But each piece is intended to vitalize some aspect of what is

generically called the Jewish Experience, and hence each constitutes a part of that experience. Taken as a whole, the installation should make the Jewish experience accessible even to those who stand at great distance from its immediate content—from the Yiddish theater and film in the irresistible work of Eleanor Antin, for example, or the severe and exigent work of Nancy Spero, which treats the brutalization of Jewish women under Nazism.

For the same reason that installation art demands participation, it is impossible to speak of any one piece without having undergone the experience it demands. One thing, however, is worth emphasizing: in following its own bent, the Jewish Museum has again connected with the mainstream of contemporary art. Nothing in the sixties was more "advanced" than the art of installation is today. In a larger sense, it is the art world that has caught up with the Museum, which has been making Jewishness—that is, a particular interest—the focus of its exhibitions for two decades.

A marvelous emblem of the reconnection is the new building this exhibition celebrates. The original Warburg mansion on upper Fifth Avenue, donated to the Jewish Museum in 1944 by Frieda Schiff Warburg, is a heavily ornamented structure in the style of François I—an architectural descendant of the church of St. Etienne du Mont in Paris or the Château de Blois in the Loire Valley. It exudes an unmistakable baronial assurance of power translated into the language of forms. Within, it is all beams, panels, monumental fireplaces, grillwork, balustrades, and elaborate stucco. There was, in the period of the Museum's ascendancy, a certain jarring contrast between the dated rhetoric of the building and its fittings and the spare abstractness of the most exemplary art works exhibited. That kind of art seemed to cry out for what the critic and artist Brian O'Doherty described as the "white cube" of the official display spaces of the modern gallery, eloquent in metaphors of purity. When in 1963 the Jewish Museum first made a bid for architectural modernity, in the construction of the List Sculpture Court, the discrepancies often ran the other way: the new addition was modernist, in its plate glass and geometry, at a time when the Museum's exhibitions had essentially little to do with modernism. There is an almost dialectical necessity in the present decision to enlarge the museum by going back to the first building and seeking to duplicate its architecture, down to the last mullion and crocket. In 1993, no more advanced a gesture could be imagined.

As a philosopher, I have always been gripped by examples of the following sort: two things, of philosophically different kinds, look alike to outward appearances. My own reflections as a philosopher of art, for example, began with the question raised by Warhol's Brillo Box: what made it art while something photographically indiscernible from it—the Brillo cartons of the supermarket—were just things? The original Warburg mansion and its reiteration by Kevin Roche raises the same sort of question, albeit less radically. The old mansion was symbolic of wealth, power, status, and aspiration. Like the wealthy of America generally, the Warburgs surrounded themselves with the appurtances of aristocracy and with the kind of art only the greatest wealth can command: Felix Warburg's pride was an amazing altarpiece by Fra Lippo Lippi, a kind of installation in the sense that its original purpose was not to be looked at but to be prayed before. Kevin Roche's structure refers to that original structure in a perfectly postmodern way. It is at a distance from its subject, the way a quotation is from the sentence quoted; and, as with quotations, its meaning and rhetoric are altogether different, even though the two structures are not intended to be visually distinct. The beauty of the architecture is that it demonstrates how, in seeking one's past, in preserving and appropriating that past, one transcends it, arriving at the same moment at the future edge of the present. If the works in this exhibition achieve this transcendence, the show will have been as great a success as the building which surrounds it. ∎

Arthur C. Danto is Johnsonian Professor of Philosophy at Columbia University and art critic for The Nation. He has published numerous books on philosophy and art.

SUSAN TUMARKIN GOODMAN

EIGHT ARTISTS:

A CULTURAL CONTEXT

The past two decades have given increased evidence of a rise in ethnic consciousness in America and the consequent use of art to express personal and political attitudes. As an increasing number of artists plumb their personal heritage as a source for their art, they have found common cause with specialized museums that provide a contemporary forum for art within culturally specific contexts. In this atmosphere, the incidence of Jewish themes among many of today's most celebrated artists has grown, and this phenomenon deserves wider recognition.

From the Inside Out: Eight Contemporary Artists illuminates the various ways artists have chosen to use their art to communicate their individual experiences of Judaism. Working in a range of styles, they draw upon their religious, cultural, and historical roots, to explore questions of personal identity as well as those which yield answers of a broader, more universal nature.

Jewish content is, however, a complex issue filled with apparent contradictions. Despite the increased acceptance of cultural diversity in our society, most of the artists participating in this exhibition are wary of interpretations that place singular emphasis on the Jewish components or references in their art. Because they work with the most challenging and advanced strategies of artistic discourse, they resist narrative labels or didactic overlays that might compromise a universalist consideration of their pieces. In fact, some of the artists are engaging issues of Jewish identity for the first time and their participation in the exhibition marks the first time their work has been seen in a Jewish context. Other artists have dealt with Jewish issues at one or more moments in their careers.

Such sensitivities have been echoed by Jewish artists throughout this century. In the early decades, a number of Jewish European artists in Paris banded together as the Circle of Montparnasse. Although they shared common religious and cultural bonds, they did not create art with Jewish themes. Quite the opposite: the price of their migration to Paris was an "undeniable loss of Jewish self-consciousness."[1] Immigrant and first-generation Jewish

artists constituted the majority of the Abstract Expressionists; some even created works that referred to Jewish liturgy. But Adolph Gottlieb expressed a representative attitude when he said, "I think art is international and should transcend any racial, ethnic, religious, or national boundaries."[2]

Gottlieb's declaration seems to have characterized the approach of Jewish avant-garde artists well into the late 1970s, when the rise of artistic pluralism encouraged the development and acceptance of diversity. This pluralism, in turn, liberated artists from the fear of being labeled parochial if they did not fit into a stylistic "norm." The result, for some, was the reintroduction of Jewish content, a phenomenon examined and encouraged by The Jewish Museum during the late 1970s and into the 1980s.[3] As the Museum reopens in the 1990s, the prominence of Jewish themes in its exhibitions of contemporary art will provide an insight into the continuity and change that is at the heart of Jewish culture.

The prevalence of religious and spiritual themes in the art of the 1990s is however more than the product of rising ethnic consciousness and artistic pluralism. The past decade has been marked by a growing sense of personal alienation and global uncertainty. The fact that Jewish content has become increasingly visible in the work of Jewish artists suggests its ability to give visual form to these anxieties. As family structures loosen and parents and grandparents age and die, the connections to a historic tradition have continued to unravel. Assimilation and the mounting rate of intermarriage have further weakened ethnic and religious identity. But a counter-trend is also discernible. It seems that the greater the loss of order in the larger society, the more acute is the need to get in touch with one's personal heritage and tradition. The use of the Jewish experience as metaphor for political or human situations, and an acknowledgment of the self as part of a group represent methods to connect rather than disengage.

As specific Jewish content in the visual arts gained momentum during the past decade, artists such as Alain Kirili, R.B. Kitaj, Louise Fishman, George Segal, and Art Spiegelman have played a definitive role in The Jewish Museum's collection and exhibition program. At the same time other, non-Jewish artists, among them William Anastasi, Anselm Kiefer, Robert Morris, Sigmar Polke, and Richard Prince, have been stimulated to create significant work which fits their universal concerns into the historical and moral framework provided by Jewish tradition and culture.

Jewish experience today takes many forms, reflecting the diversity within contemporary life and culture. In attempting to use aspects of Judaism to forge a personal identity, an artist must sort through a maze of public and private voices, weighing the forces of cultural traditions and personal history, along with other demands such as economic class and sexual identity. The particular choice of theme reveals a great deal about the fusion of self-image and artistic expression. Among the works in the present exhibition, many individual, social, and communal issues, when viewed through a Jewish lens, become rich in historical allusion (Nancy Spero, Barbara Steinman, Eleanor Antin), spiritual resonance (Moshe Gershuni, Lawrence Weiner), personal reference (Ilya Kabakov), or social and cultural symbols (Christian Boltanski and Clegg and Guttmann).

As these artists explore issues related to the Jewish experience, they reveal consistencies and contradictions inherent in the experience itself. The works frequently make use of provocative, even disturbing, imagery that sometimes questions traditional Jewish practice and at other times attempts to force the viewer to reconsider his or her perception of Jewish mores and history.

■

[1] Arthur A. Cohen, "From Eastern Europe to Paris and Beyond," in The Circle of Montparnasse: Jewish Artists in Paris 1905-1945, exh. cat. (New York: The Jewish Museum/Universe Books, 1985), p. 66. This "loss" enabled the Montparnasse artists to adopt the much broader, prevailing Parisian styles and trends. Even in cases where "self-consciousness" was not denied, some artists continued to avoid official identification with their roots. Marc Chagall, for example, whose Jewishness predominated in his work, chose not to be included in exhibitions of an explicit Jewish nature toward the end of his career.

[2] Quoted in Painting a Place in America, exh. cat. (New York: The Jewish Museum, 1991), p. 67.

[3] The phenomenon was manifest in the 1970s in Jewish Museum exhibitions of often overlooked artists such as David Aronson, Anatole Kaplan, Erich Brauer, and Jack Levine and in the 1980s by June Wayne and Maurice Golubov, and in the exhibitions Jewish Themes/Contemporary American Artists and Jewish Themes/Contemporary American Artists II.

E L E A N O R A N T I N

Antin's mixed-media installation *Vilna Nights*, devoted to the experience of the Eastern European city where Jews lived and to the Yiddish silent film, evokes nostalgia as well as sorrow for the demise of the *shtetl*. Antin turns art into conceptual theater, transmitting her drama by means of "multiple screens to present discrete images of people who represent a vanished life." Her installation space is defined by "a life-size stage set consisting of a ruined landscape and a fragment of a bombed out courtyard in the ghetto." Caught inside the boundaries of Antin's world, the viewer becomes an accomplice to her nostalgic scenarios. The narrative scenes which depict the disappeared Yiddish life are shot on 16 mm film and transferred to video projectors for life-size rear-projection onto three windows serving as screens. Clearly, they are fantasies staged by the artist, yet these films are so fully realized in color and confer such an abundance of incidents that the set takes on the aura of reality.

The ambiguity of these film-fantasies rests in Antin's mix of media and in the content, which reflects both a personal as well as generic Jewish experience. For the better part of her creative years, Eleanor Antin has developed a series of personas—alternate selves—that allowed her to engage issues of historical importance. These personas were drawn from within and expressed some aspect of her own personality, desires, and anxieties. In her latest work the fictional selves come together and the artist, herself, acknowledges responsibility for the creation, production, and direction of *Vilna Nights*.

This new installation follows directly from Antin's previous feature film, *The Man Without a World*, and is a manifestation of her continuing and deep interest in Yiddish life and culture during the early part of this century. Both this work and its predecessor have been part of the artist's journey to uncover her own roots. Antin attributes her passion for Jewish culture to the politically Jewish, left wing atmosphere in which she grew up. Her mother, who had been an actress in the Yiddish

...I'm dealing with the specifics of memory and desire and fantasy as they relate to my cultural past, which is a Jewish, Eastern European past—whose disappearance and paradoxical presentation I hope to address to these issues of memory, history and desire.[1]

theatre, operated a number of hotels in the Catskills. Her last one, a haven for elderly Eastern European Jews, placed heavy emphasis on Jewish cultural programs and was certainly a spawning ground for the artist's deep fascination with this environment.

[1] From artist's statement to The Jewish Museum, September 1992.

Vilna Nights employs a wide variety of media (installation, photography, film, performance, writing, sculpture), genres, and styles. The courtyard is constructed in an expressionistic mode with angular walls and heavy overhung elements. It must be glimpsed through a demolished wall reminding us of the destruction of the world of European Jewry during World War II. The exterior wall which is breaking apart reveals a moonlit scene of a portion of a burnt-out street in the Vilna Jewish quarter. Through the three casement windows in the courtyard it is possible to "glimpse typological images suggesting rooms haunted by the ghosts of the former inhabitants searching for their lost lives." By observing fragments of these vanished lives on film, the artist conveys the sense that the protagonists "continue living out their interrupted lives." This physical setting is accompanied by an acoustic tape composed of intermittent snatches of the sounds of courtyard life. Antin splices together numerous incidents to create an ethnic, social, and religious identity. By using multiple screens that show

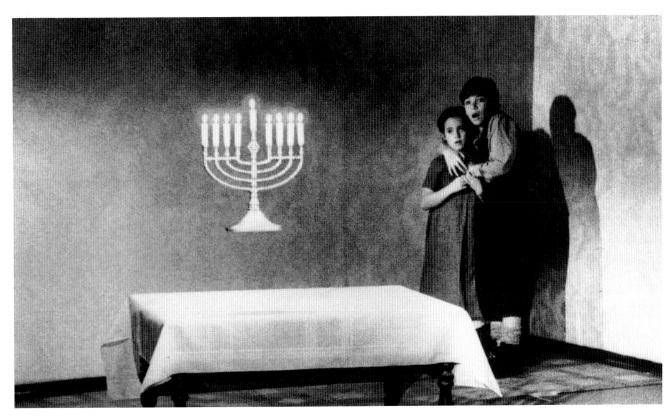

▲ Still from *Vilna Nights*, 1993
Mixed-media installation

various scenes simultaneously, the artist creates a loose, fragmented accumulation from diverse bits of information.

Antin's installation recreates the *shtetl* environment as a frontal view of a lost world. While filled with the commonplace details of life, *Vilna Nights* also emphasizes the subjective framework and narrative structure that shapes the constructed experience of memory. In her sculptural stage set, architectural fragments are juxtaposed with the fictional elements of the film footage to create a mélange of experiences. *Vilna Nights*, made some five decades after the demise of *shtetl* culture, is Antin's means of demonstrating that "time collapses into itself as layers of life flow simultaneously into a mesh of memory and dream."

[2] Quotations are from a statement by the artist to The Jewish Museum, September 1992.

Christian Boltanski's multimedia assemblages and wall reliefs are constructed from perishable materials, including anonymous photographs and used objects. They evoke the lives of his Jewish predecessors, and reflect an ambiguous interweaving of cultural references as well as personal and collective memories.

Born to a Jewish father and a Catholic mother, in Paris, just after the liberation of the city in 1944, Boltanski was profoundly influenced by the havoc and horror of World War II and its aftermath. Many of his installations have made use of personal effects and photographs, often evoking associations with the Holocaust and the unknown victims of war, as well as memory and loss of childhood.

For this exhibition, Boltanski has constructed a museum within The Jewish Museum—*Museum of the Bar Mitzvah*. To compose this work, he has amassed evocative photographs and objects borrowed from families of bar and bat mitzvah children. The photographs are laid out on walls in the gallery, and each bears testimony to the event it documents. The artist thus creates a context for the photographs which leads us to view them as authentic records of personal experience. In reality, the artist has created a fictional construct; once the photographs are separated from their original context they communicate in a generic manner only. There is no determining factor in the positioning of the photographs, as they are arranged in an arbitrary pattern to form a unified entity. Incorporated into Boltanski's work, they no longer refer to individuals or families at a particular bar mitzvah, but rather they represent a collective rite of passage.

The images are culturally, historically, and socially loaded, and while presented in an objective mode, they take on emotional impact because their elements have significant inherent associations in the life of many Jews. In this work Boltanski examines the current state of the bar mitzvah, a rite of passage whose origins date back more then seven hundred years, marking the transition from childhood to adolescence at age thirteen.

Boltanski is partial to amateur photographs of anonymous people— the kind generally overlooked. Nonetheless, these images, snapped

I think there's a strong Jewish component to my work. I have always dealt with the concept of memory, which I'm sure is a Jewish characteristic. The Jews speak of a world which has disappeared, so memory plays an important role for them.[1]

casually and meant to document an event, transcend the private circumstances under which they were made. The artist emphasizes the cultural common denominator in order to consider its accepted significance and posit new or additional meanings. Boltanski

[1] From an interview by Bracha Ettinger, in *Christian Boltanski: Lessons of Darkness*, exh. cat. (Jerusalem: The Israel Museum, 1989), n.p.

reminds the viewer that a work of art is not ideologically neutral; implicit in its existence is a point of view.

The installation also contains a number of vitrines filled with the actual artifacts that were used as a part of the bar/bat mitzvah ritual and celebration. Using as his model the exhibition techniques of a late 19th-century museum of anthropology rather than of a museum of contemporary art, he has presented these artifacts in five vitrines. (The objects were lent by different families for this installation and include bat mitzvah memorabilia as well.) Even the way Boltanski has labeled the objects in the cases, including their raw data only, discourages the viewer from focusing on their personal nature. By creating a work of art comprised of over one hundred photographs of a similar subject as well as multiples of specific objects, it is apparent that none of the material is being shown for its own sake, but in order to focus on the conditions under which things are exhibited and viewed.

During the early years of this century in America, it became customary to follow the ceremony with some kind of festive meal. For the most part, the receptions were modest and small. The bar mitzvah was viewed by the immigrant generation as a symbolic and ceremonial occasion; however, as the economic and social situation of Jews improved in the late 1920s, the social component of the bar mitzvah began to rival, if not to eclipse, its ritual function. In fact, gift giving was a frequent companion to the ritual ceremony. Thus the bar mitzvah party evolved its own ritual and has continued, to date, in this elaborate form.[2]

In *Museum of the Bar Mitzvah* Boltanski critiques the social structure of the American bar mitzvah through dispassionate replication and documentation, thereby directing our attention to the meaning of this Jewish ceremony in our society. By so doing, he makes us conscious of the invisible forces that shape our lives.

▲ Study for Museum of the Bar Mitzvah, 1993
Mixed-media installation

[2] For information on the American bar mitzvah, see *Getting Comfortable in New York: The American Jewish Home*, exh. cat. (New York: The Jewish Museum, 1990), pp. 65-66.

C L E G G & G U T T M A N N

As Conceptual artists, Clegg and Guttmann investigate how meaning is created, transmitted, and received. Their work resists facile interpretation and requires a consideration of the multiple visual and conceptual themes suggested by their Cibachrome photographs. Disregarding the separation of sculpture, photography, and installation, they stretch and conflate the boundaries often used to define art. The artists have stated that one of the constant concerns in their work is "the idea of embedding art in a larger context."[2] To this end they consider such concepts as ideology, categorization and methods of production.

Their new work, *Selections from the Periodical section of The Jewish Theological Seminary: the section beginning at "Palestine Exploration Fund (Quarterly)" 1926-1989 and ending at "Rhode Island Jewish Historical Notes" 1955-1990*, presents photographs of shelves of journals in the periodical section of The Jewish Theological Seminary library. The library functions as a subject to be addressed without idealization or personal involvement, yet by choosing this library as a theme, they focus on an institution which redounds upon their own identity.

Life-size color photographs of shelves are mounted on either side of five constructed library units. By combining low wooden structures with photographs, Clegg and Guttmann allow the referential nature of the journals to join with the formal properties of the photographs as physical objects. The viewer is in direct contact with the content represented by the bindings, and the profusion of titles and progression of dates and numbers depicted on the spines evoke a sense of history. The journals, in German, English, French, Spanish and Italian, are shelved alphabetically and numbered by years. They introduce subjects—identity, statehood, separation, nationalism, Zionism, religion—that have shaped contemporary thinking on the state of Judaism internationally, giving a sense of the diversity and scope of writing on issues of importance from the mid-19th century to the present. The Orthodox, Conservative, Reform and Reconstructionist movements are represented

in this array with publications of their respective rabbinic bodies. The sculptural environment created by the library shelves, leads us to consider the representation of knowledge and the means by which it is compartmentalized and packaged.

Our preoccupation with history comes naturally to us, being Jewish. Since both our families moved around the world often, our identity could have not been derived from any particular place. Thus preoccuption with history becomes a form of compensation.[1]

[1] From artists' statement to The Jewish Museum, April 1993.
[2] Ibid.

Another layer is added to this simulated library by inclusion of what the artists call a 128-year calender which represents the number of years covered by the journals in the photographs. As libraries often contain portraits of individuals who have made contributions both to society and the library itself, Clegg and Guttmann have chosen to include in their installation re-photographed portraits from a room in the Seminary Library called the "Hall of 100." By using these photographs, originally commissioned from Bradford Bachrach, the artists radically alter their context, forcing us to reflect on the artifice, staged ambience and stylized pose employed in the visual representation of power and authority. Superimposed on each of the portraits is a 12 month calender as well as the listing of all the journals in the library published in that year.

While the viewer is led to ponder these library journal texts, written through the century about Jewish activity and thought, a strong

▲ Study for Selections from the Periodical section of The Jewish Theological Seminary, 1993
Mixed-media installation

connection is also made between the library and the individuals whose donations have sustained it. The library itself is portrayed as a symbolic seat of scholarship and knowledge. By making photos of actual library volumes, and creating an indexing system based on chronology, the artists reconfigure its constituent parts, suggesting a reconsideration of traditional categories and boundaries.

MOSHE GERSHUNI

Symbols and liturgical phrases derived from Jewish history and Israeli reality infuse the art of Moshe Gershuni. Obliterating references to pictorialism, Gershuni often addresses abstract concepts that seem beyond visualization, relating to religious belief, the Holocaust, and death.

His painting *Ani Yodea* is a single piece comprising seven elements, each one an independent work, but similar in size and character and functioning as parts of a whole. Placed next to one another and read from right to left, the seven works create the Hebrew phrase *ani yodea*, "I know." A central swath embeds a single Hebrew letter in each work, creating a significant presence in the dense vegetal ground. Although the color green, which dominates these paintings, suggests life and growth, in this work Gershuni creates images that have the capacity to conflate concepts of life and death.

The rich green color and title "I Know" has evolved from the artist's need to confront deep existential questions. The affirmation "I know" refers to the moment when the individual acknowledges that a person's days are numbered. This acceptance and understanding must be internalized before it is possible to say "I know". The paintings should be viewed in the context of Psalm 23 in which the mourner is comforted with the image of the green pastures that await the deceased, who will be protected by God, the supreme Shepherd. The process of getting old prepares us to die, as God prepared Abraham and Moses for their demise. Death appears to be a form of salvation; thus Gershuni attributes a readiness for death—"I Know"—to a form of religious fulfillment.

The surfaces of the seven abstract paintings are dense with organic gestural marks interacting in a shallow pictorial space. Unexplained hand prints along with plant forms emerge from the green-blackness and work their way through the canvas. A free, liquid feeling results from soaking the paper with oil or turpentine and working into a wet surface, an activity performed by the artist on the floor, on his knees. Gershuni created the letters by covering the entire surface and then erasing the liquid paint with a sweeping gesture. An inner light seems to emanate from the letter forms giving them a disembodied ghostlike quality.

Gershuni has also created a series of painted bowls, plates, and urns decorated with biblical quotations, painterly markings, and Stars of David. As in his painting, the texts

Yes, I'm a Jew with all the mysticism that this implies. I'm Israeli because I'm Jewish. There isn't any point in my being here, in Israel, otherwise.

I was born here, and the people I care about most live here, for better and for worseI am Israeli because I am Jewish, because the blood flows in my veins in a Jewish way, in a Jewish rhythm, but also for all the old (and wrong) reasons, to wit, that others have decided for me that I am obliged to live in the context of independence and self-sovereignty. There is no other place. In short—sound, sane Zionism.[1]

[1] Quoted in *Kav*, nos. 4-5 (November 1982)

on the pottery are steeped in Israel's national spirit and the tormented history of the Jews. The six urns entitled *(Green Pastures), "To show that the Lord is upright…"* carry a quotation from Psalm 92:15. They are arranged sequentially and their letters, from right to left, read "They shall bear fruit even in old age: they shall be ever fresh and fragrant." The poetic reference on Gershuni's urns refers to the human condition, in particular that of an aging person who can still be creative and vital. The simple utilitarian forms and humble smooth surfaces

◄ **Ani Yodea (I Know)**, 1992
Oil on paper
series of seven, each 63 x 47 1/4 inches

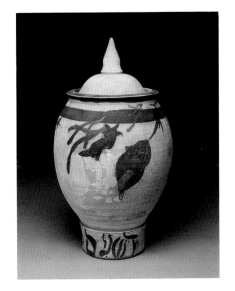

▲ **Detail from (Green Pastures)**
"To show that the Lord is upright…" 1990
Six ceramic urns with slip glaze
each 15 3/4 inches high x 9 inches (diameter)

are nearly free of incident, while their swelling volumes and natural color engage the viewer in the flow and rhythm of the poetry. Jewish symbols and Hebrew letters were applied with a brush to the lower rim, and the shape of the letters is influenced by traditional calligraphy, in which certain letters may be elongated, sinuous, or curling.

Pottery, as an enduring material, is often associated with a sense of antiquity. For Gershuni, the fragility of the clay may suggest the advanced age mentioned by the psalmist. However, the artist negates the usual association of urns with death by inscribing Psalm 92 directly onto the urns, which reaffirms life and looks toward the fertility of old age.

Thus the paintings, green with life, connote death, and the urns, often symbols of cremation, suggest life, attesting to their ability to evoke interpretations in an artistic language that allows for inner contradictions and ambiguity. The underlying implication of the artist's continuous use of symbols and language is the idea that these forms serve to bind members of a group together while conveying a historical narrative that unifies the group.

I L Y A K A B A K O V

Ilya Kabakov's work is grounded in his personal experience of growing up in the Soviet Union. Having suffered the effects of life in a society where the dogma and ideology of a totalitarian state seemed to destroy the quality of life, he has opted to make art that directly addresses the dehumanizing circumstances of Soviet existence. While his crowded, decrepit spaces comment on the physical discomforts of life under Communism, they also focus on the emotions needed to survive the oppression of Soviet society.

Kabakov had to endure not only the difficulties faced by all Soviet citizens, but the additional burdens of living in a society hostile to Jews. Like most Soviet Jews, he grew up with an awareness of his ethnic identity, though with no knowledge of Jewish religious practices and traditions. "I think it's so deep in my mind and my feelings that perhaps it's behind them. But I have a very strong feeling that I am a Jew."[2] Both Kabakov and his mother survived great adversity in the years of Nazi and Stalinist anti-Semitism. But this heightened his identification with his heritage, and created an especially strong bond with his mother, whose own mother was so non-Russian as to be "only literate in Hebrew."[3] These were significant factors in the formation of Kabakov's sense of self, affecting him on "an unconscious level, where all decisions are actually made."[4]

Russian life is boldly examined in Kabakov's work. The description of its physical characteristics often functions as metaphor for conditions implicit in the now defunct Soviet system. A leader of a generation of artists whose activities were not sanctioned by the authorities in Moscow, Kabakov was one of the earliest artists to dare to treat official Soviet society and art with irony and irreverence. He obliquely transmitted social criticism by describing life in a system which disregarded the dignity of human life. By taking us into a Moscow communal apartment and evoking the confined life

experience of the average Soviet citizen, or into a communal toilet, Kabakov comments on the Soviet citizen's loss of individuality. The profusion of detail in Kabakov's installations speaks of the world he has left behind; of its congestion, chaos, obscurity, loss of choice, the fatuousness of official Soviet aesthetics, and the personal indignities

As for inspiration: it was fear and pity....On the conscious level, my work in its subject, form, etc. wasn't really connected to religious identity, but on the unconscious level, where all decisions are actually made, everything probably grew out of my ethnic identity.[1]

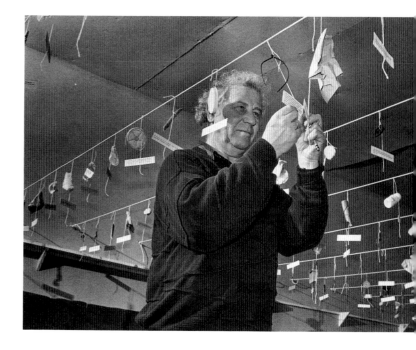

[1] From artist's statement to The Jewish Museum, September 1992.

of the system. His texts and rooms are manifestations of the attempts of the average Soviet citizen to build personal worlds.

Kabakov's later installations have been accompanied by substantial literary documents. In *Mother and Son* the artist leaves the more literal spaces of his past work to explore the interior world of his intense and complex relationship with his mother. After her husband abandoned his family at the end of World War II, Kabakov's mother devoted herself to her son's schooling, entailing years of hardship, wandering, and deprivation. The poignant autobiography of Kabakov's mother, combined with faded government propaganda photographs, lines the walls and describes the personal hardships and political oppression she endured throughout her life in a totalitarian society.

In this installation Kabakov leads us from the oppression and distrust implicit in the Soviet system to the devotion shared by artist and mother communicated through his own confessional fragments. Joined with the debris of every day life, these texts are suspended throughout of the room and illuminated by naked overhead light bulbs. His autobiographical stream of consciousness covers the entire spectrum of emotions from the petty annoyances of life to intimate revelations of personal angst addressed to "Mama."

The realization that inextricable bonds unite mother and son is expressed by Kabakov in his text: "Sometimes it seems to me that I am fulfilling a 'plan', a 'program' which you put into me...Any reaction of mine to life is your reaction, a copy of yours."...

A dense sentimental ambience is created by this profusion of elements, bound together by the voice of Kabakov singing 19th-century Russian, Gypsy and French songs to his mother. The surrounding darkness is like a womb for the sentiments which can only now be expressed to one another. But it is too late and an unbridgeable gulf separates them. The installation is not a chronicle of bitterness however, it is about communication, gratitude and love. As we journey with our flashlights through the rows of notes from son to mother, we feel the human emotion which this oppressive society was not able to stifle.

▲ Preliminary drawing for Mother and Son, 1993
Mixed-media installation

[2] Quoted in *The Jerusalem Report*, September 26, 1991.
[3] *He Lost his Mind, Undressed, Ran away Naked: section 4, Album of my Mother*, exh. cat. (New York: Ronald Feldman Fine Arts, 1990), p1.
[4] From artist's statement to the Jewish Museum, September 1992.

N A N C Y S P E R O

Spero is an artist concerned primarily with gender, and her work projects her activist feminist stance. It is her belief that women have essentially been written out of history. By taking strong female figures from the past and manipulating their images, she reveals qualities of strength and endurance that tell a new story about women. Confronting the suppression and subjugation of the female throughout history, Spero became aware that the deeds of Jewish woman have also been ignored. In this exhibition, she focuses attention on a number of heroic Jewish women in history and the incidents that defined them.

The wall itself is the surface of Spero's art, providing a solid, yet simultaneously impermanent surface upon which to work. Hand-printed letters as well as images are pressed or rubbed onto the wall from polymer plates. This manner of printing directly onto the wall in repeated, scattered, or compacted images results in an ephemeral, immediate, almost graffiti-like quality.

The *Ballad of Marie Sanders, The Jew's Whore* is a wall piece whose text is taken from a poem by Bertolt Brecht, written about 1934. It relates an incident during the Nazi era when a Gentile woman was humiliated and tortured for having had sexual relations with a Jew; she was marched down the street to her death accompanied by the roll of drums. Spero's hand-printed text is joined by a color image of a bound and gagged nude woman with a noose around her neck, taken from a photograph found in the pocket of a Gestapo officer. The woman's plight and bodily torment become a metaphor for the struggles of women against the physical and mental indignities inflicted upon them. This piece has been installed in other locations, and each time, it is configured differently, in response to the specific space it occupies.

Spero's second wall piece, *Voices: Jewish Women in Time*, was conceived for this exhibition. Intermingled with *Ballad of Marie Sanders*, it embraces a seemingly arbitrary array of images of Jewish women in the 20th century, spread out on the museum wall as they would be on the pages of a manuscript. The fragmented photo images include such diverse subjects as Israeli women marching to protest violence

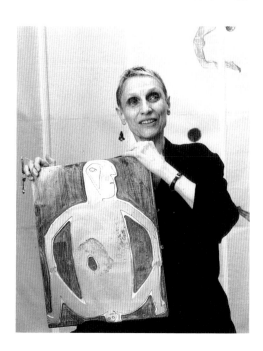

Jewish references are particularly in evidence in my War Series (1966-70). While primarily reacting to the Vietnam War, a series of paintings referred to the Holocaust, swastikas, the Star of David, victims and crematoriums. Since the mid 70s I have concentrated on investigating the status of women from past to present, i.e., class, race, occupation, culture, time, etc. This concern embraces the inquiry and representation of Jewish women. It is relevant at this point in my career to be showing at the Jewish Museum, touching base with my origins as a Jew.[1]

[1] From artist's statement to The Jewish Museum, September 1992.

against women, Warsaw ghetto victims, and contemporary Jewish women in the peace movement. By giving voice to the causes and struggles of these women who have been left out of the larger historical picture, Spero attempts to reinscribe their experiences, to validate them in the frame of history. The images are combined and juxtaposed with poetry by contemporary Jewish women, including Irena Klepfisz and Nelly Sachs, whose poem *That the Persecuted May Not Become the Persecutors* is disposed in a column next to a knife which bisects the wall from top to bottom. Its painterly surface reveals forms which evoke the Holocaust themes referred to in the poetry. These Jewish women thus join Spero's expanding cast of female characters from prehistoric times to the present.

Spero transposes images from a wide range of sources, using them not only to reinforce the evocative power of the work, but also to direct the viewer's attention to the major role of the Jewish woman in important areas of human activity. In her female icons of power, she suggests a scenario for women in command of their own history. Her art is affirmative in the sense that she aims to help women bring about their enfranchisement by picturing not only their victimization but also their empowering deeds.

▲ Ballad of Marie Sanders, The Jew's Whore, 1991
Wall printing installation, Von der Heydt Museum,
Wuppertal Germany

B A R B A R A S T E I N M A N

By dematerializing the art object in her multimedia installations, Barbara Steinman arrives at an integrated, radical approach to the conception and presentation of art, in which she moves from still photography to video, from abstraction to image, from symbol to narrative in a seamless and unself-conscious way.

Steinman resists verbal interpretation of her work in favor of a firsthand experience communicated through its own vocabulary of sights and sounds. In subtle and deceptively simple ways, she uses photography and video to transmit abstract concepts. Though her work transcends language, it incorporates words and ready-made objects as informational cues, in order to sensitize viewers and set off emotional responses.

Steinman focuses on the generic identities of those who have been victims of political oppression. The ironic combination of words that make up the title for the multimedia installation *Of a Place Solitary. Of a Sound Mute* derives from Osip Mandelstam's interpretation of the word "deaf": "said of a place, it is solitary, godforsaken, overgrown; of a wall, blank; of a rumor, vague; of a season, dead; of a sound, mute, hollow...the result of which is silence....."[2] The artist has said that this installation is "as much about elegy as warning." Images, movements, and sounds elicit different levels of response. There is a photograph of an outstretched arm with palm opened toward the viewer; beside it, small numbers have been etched into the surface of a sheet of glass. As the eye imaginatively transposes the numbers on the glass to the flesh of the arm, we are reminded of the millions of concentration camp victims transformed into numbers, their identities lost or forgotten. Within the gallery space there is a parabolic structure with a screen at its base showing an hourlong video of 73 gold rings dropping one after another into a metal container. An echoing sound is heard as the rings fall, and the space slowly becomes filled.

Mandelstam's words "of a wall, blank" are the conceptual starting point for *Signs*. As it relates to the silencing of people and their subsequent numbering, it is connected to *Of a Place*. In *Signs*, Steinman interprets complex personal and historical issues concerning the silencing of ideas and thought. A profusion of electric signs flash the single word "silence" in red, against a blank white wall. The effect is forceful, yet we are uncertain how to interpret

the message. What might be taken as a request if there was only one sign, becomes an order when they are multiplied. As a command, who directs us to obey? The signs, programmed by computer to flash on and off in irregular sequences, impose themselves on our consciousness.

The fact of being Jewish has informed my experience. I am interested in issues of identity and how particular and universal impulses can coexist.[1]

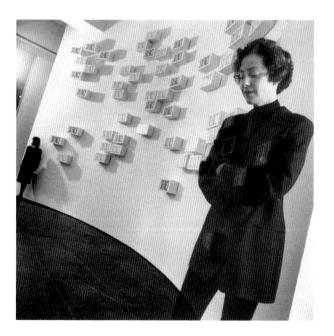

[1] From artist's statement to The Jewish Museum, March 1993.

While they refer to silence, they are visually noisy, implying that there is no escape from the threat of totalitarian measures that would silence the individual voice.

Steinman's Jewish heritage, which has been reflected in a number of works, has fostered an empathy with the dispossessed of the world. In both *Of a Place* and *Signs*, the situation in which Jews find themselves, both as victims and as perpetrators, is central. Although *Of a Place* elicits explicit Holocaust associations, the two works together carry universal implications and common fears. The red "silence" signs, with their insistent random flashing, represent a type of memorial site as well as a form of alert to the dangers that threaten our humanity. Steinman perceives this piece as "an institutionalization and suppressing of individual voices (or thoughts); as a kind of mapping system with lights and world-view which speaks of ethnic cleansing and suppressing of cultural variation; as a peaceful sight of meditation and contemplation in the midst of chaos...."[3]

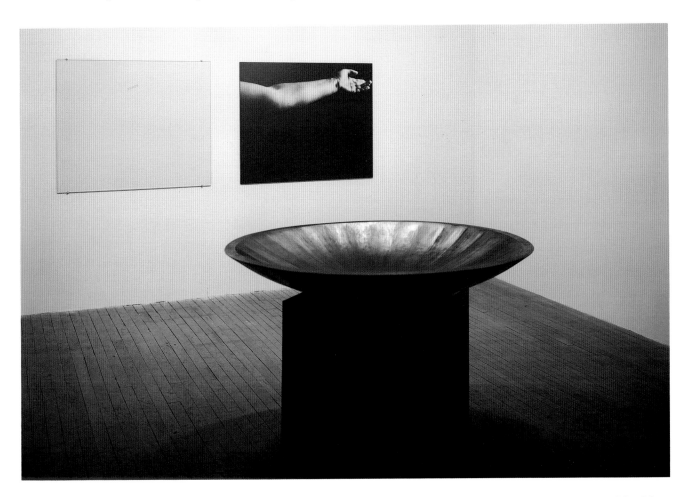

▲ Of a Place Solitary. Of a Sound Mute, 1989
Mixed-media installation

In both works, the concept of "muteness" is used with irony. *Of a Place* includes the sound of rings dropping whereas in *Signs* the word "silence" seems to cry out. In each, the intensity of reaction seems to be internalized, creating a situation of silence. Using a mix of stimuli and an elliptical approach, Steinman asks us to confront our preconceptions of history.

Although Steinman's works function as monuments to the dead, they do not explicitly accuse or moralize. They engage us visually, while insisting that we address the countless situations of intolerance, domination, and suppression encountered in both the political and the human arenas.

[2] Clarence Brown, *Mandelstam* (London: Cambridge University Press, 1973), p. 241.
[3] From artist's statement to The Jewish Museum, October 1992.

L A W R E N C E W E I N E R

Lawrence Weiner manipulates the elements of language, stripping the letter, word, or phrase of predictable meaning and reformulating it with new and unexpected significance. As with much of his work, this installation consists of letters pristinely painted directly onto the gallery walls, so that the familiar characters become formal abstract elements which interact on the flat ground of the surfaces they occupy.

By focusing on the physicality of the letters and words, Weiner uses language not to document a concept, but as the art object itself. In 1967, he came to believe that language alone was sufficient to transmit visual meaning, and he has recently observed that "the utilization of language to represent and function as an object [itself] allows the presentation of a work as an object-ive reality, not as a metaphor."[2] Through such formal devices as symmetry and repeated patterns, along with the use of copper, pewter and silver metallic sign enamels, Weiner enhances the visual impact of the work. At the same time, he emphasizes idea over execution, and the removal of the artist's hand is demonstrated by the painting of the letters by a professional sign painter.

The acceptance of language itself as a material (THE WORD) is almost a Jewish Theme....[1]

Weiner's intention, however, is to engage the viewer, who ponders the associations derived from the artist's mix of words. In his piece for The Jewish Museum, *Niter and Brimstone, Kept Apart*, it is necessary to look at each word and then consider the collective impact of the combinations. Brimstone, an archaic word for sulfur referred to in *Genesis*, is one of the most abundant elements in the universe. The Bible states that brimstone (sulfur) rained upon Sodom and Gomorrah (Genesis 19:24). Thus, the Bible uses the word brimstone, which is known for its flammability, to symbolize torment and destruction. Niter, also known as saltpeter, is a mineral of potassium nitrate, and its discovery has been attributed to Chinese Taoist alchemists in the ninth century toward the end of the Tang Dynasty.[3] It was valued for use in farming and agriculture. However, when combined with other elements, its primary function was in the manufacture of gunpowder and fireworks.[4] The third phrase in Weiner's

work is "kept apart." Sulfur and saltpeter are benign substances when kept apart or taken by themselves. Mixed together, they become destructive: the combination of the two yields an explosive.

By focusing our attention on the words themselves, the artist allows

[1] From a letter to The Jewish Museum, March 1984.

for a consideration of multiple interpretations. Weiner has selected the Hebrew word *Nifrad* for kept apart. These words, in both English and Hebrew, are intended by the artist to refer specifically to Jewish dietary laws. In traditional Judaism, the separation of meat and dairy products is a central dietary prohibition, and it is forbidden to combine such foods.

Weiner employs words—niter, brimstone, and kept apart—to challenge viewers to confront their individual attitudes about the contemporary relevance and validity of Jewish dietary prohibitions. Considering the words as they are joined together may lead us to a wide range of conclusions: at one extreme, that all hell will break loose if meat and milk are mixed; at the other, that the prohibition is anachronistic in this day and age.

For Weiner, language has the capacity to refer to ideas and concepts without relying on illusionistic devices and without the intervention of personal gesture, expression, or value judgment. The archaic nature of the

▲ **Niter & Brimestone Kept Apart**, 1993
Installation drawing

words that comprise this work create an emotional distance—a distancing the artist considers necessary in the cognitive process that activates the viewer. By creating works that must be grasped conceptually, Weiner has restructured traditional attitudes toward making, exhibiting, and viewing art, putting language to use as a material for thought.

[2] From artist's statement to The Jewish Museum, September 1992.
[3] See George B. Kauffman and Zie Anna Payne, "Contributions of the Ancients," *Chemistry*, 46, 4, 1973, pp. 6-10.
[4] The invention of explosives can be traced back to the Chinese who used them for fireworks and military purposes in the Southern Sung Dynasty (1127-1279).

WORKS IN THE EXHIBITION

ELEANOR ANTIN

Vilna Nights, 1993
Mixed-media installation
Installation courtesy of
Ronald Feldman Fine
Arts, New York

CHRISTIAN BOLTANSKI

Museum of the Bar Mitzvah, 1993
Mixed-media installation
Installation courtesy of
Marian Goodman
Gallery, New York

CLEGG & GUTTMANN

Selections from the Periodical section of The Jewish Theological Seminary: the section beginning at "*Palestine Exploration Fund (Quarterly)*" 1926-1989 and ending at "*Rhode Island Jewish Historical Notes*" 1955-1990, 1993
Mixed-media installation
Installation courtesy of
the artists

MOSHE GERSHUNI

(Green Pastures), "To show that the Lord is upright...", 1990
Six ceramic urns with
slip glaze,
each 15 ¾ inches high x
9 inches (diameter)
Givon Art Gallery, Ltd.,
Tel Aviv
Urns made in
collaboration with
Dani Davis

Ani Yodea (I Know),
1992
Oil on paper
Series of seven,
each 63 x 47 ¼ inches
Givon Art Gallery, Ltd.,
Tel Aviv

ILYA KABAKOV

Mother and Son, 1993
Mixed-media installation
Installation courtesy of
Ronald Feldman Fine
Arts, New York

NANCY SPERO

Ballad of Marie Sanders, The Jew's Whore
(Brecht), 1993
Wall printing installation
Installation courtesy of
Josh Baer Gallery,
New York

Voices: Jewish Women in Time, 1993
Wall printing installation
Installation courtesy of
Josh Baer Gallery,
New York

BARBARA STEINMAN

Of a Place Solitary. Of a Sound Mute, 1989
Mixed-media installation
The Canada Council Art
Bank/La Banque
d'oeuvres d'art du
Conseil des arts du
Canada, Ottawa

Signs, 1992
Electric signs, computer
interface program
Galerie René Blouin,
Montreal

LAWRENCE WEINER

NITER & BRIMSTONE KEPT APART
1993
Language + The Material
Referred To
Installation courtesy of
the artist and
Marian Goodman
Gallery, New York

ELEANOR ANTIN

Work in progress.

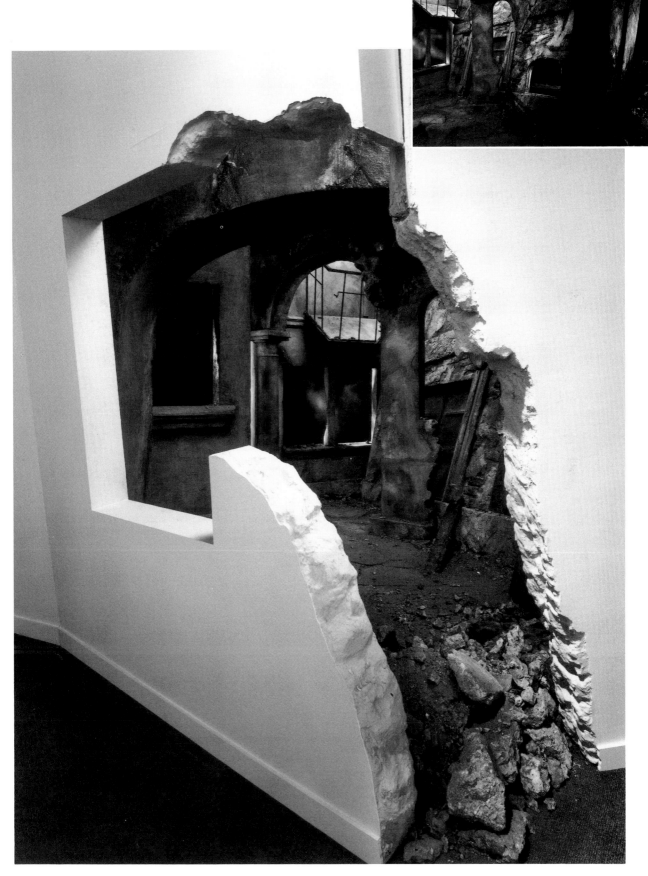

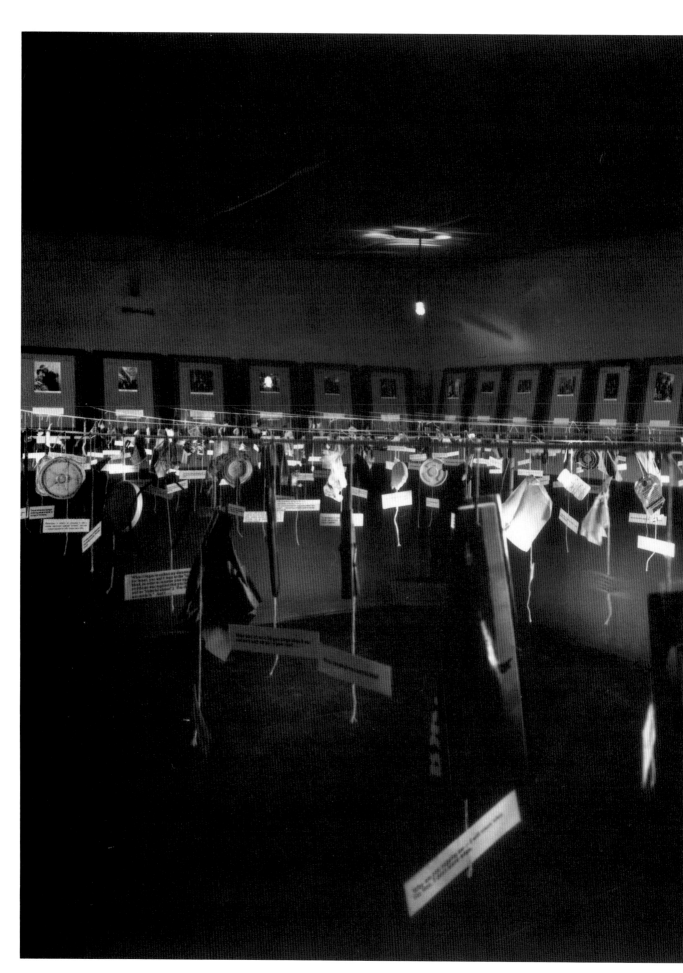

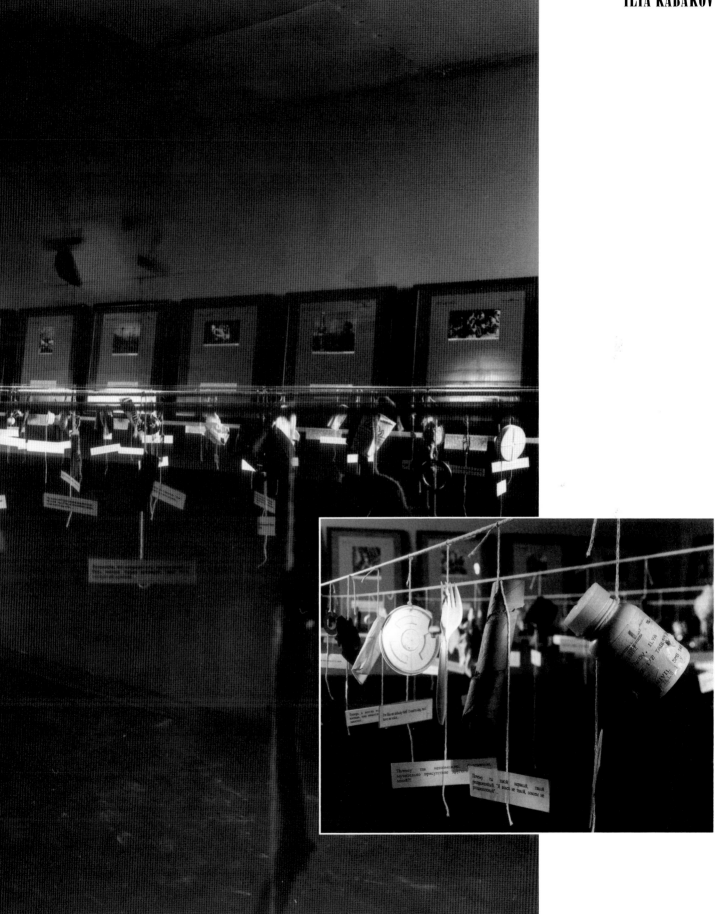

NANCY SPERO

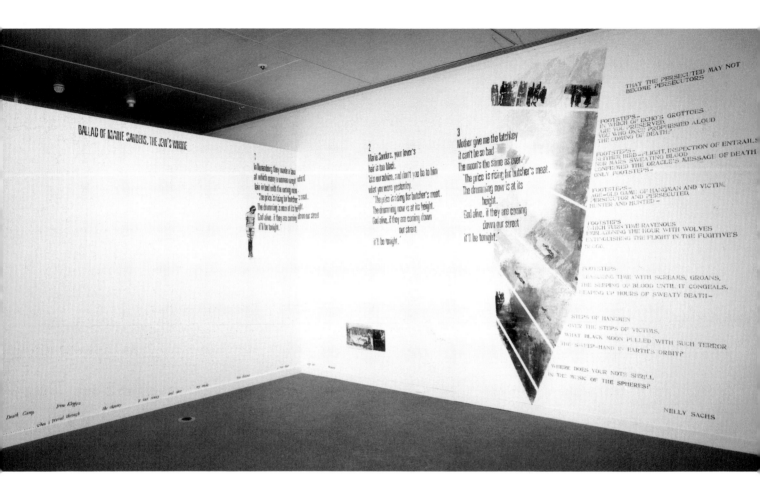

BALLAD OF MARIE SANDERS, THE JEW'S WHORE

1
In Nuremberg they made a law
at which many a woman wept who'd
lain in bed with the wrong man.
"The price is rising for butcher's meat.
The drumming now is at its height.
God alive, if they are coming down our street
it'll be tonight."

2
Marie Sanders, your lover's
hair is too black.
Take our advice, and don't you be to him
what you were yesterday.
"The price is rising for butcher's meat.
The drumming now is at its height.
God alive, if they are coming down
our street
it'll be tonight."

3
Mother give me the latchkey
it can't be so bad
The moon's the same as ever.
"The price is rising for butcher's meat.
The drumming now is at its
height.
God alive, if they are coming
down our street
it'll be tonight."

THAT THE PERSECUTED MAY NOT
BECOME PERSECUTORS

FOOTSTEPS—
IN WHICH OF ECHO'S GROTTOES
ARE YOU PRESERVED,
YOU WHO ONCE PROPHESIED ALOUD
THE COMING OF DEATH?

FOOTSTEPS—
NEITHER BIRD—FLIGHT, INSPECTION OF ENTRAILS
NOR MARS SWEATING BLOOD
CONFIRMED THE ORACLE'S MESSAGE OF DEATH
ONLY FOOTSTEPS—

FOOTSTEPS—
AGE—OLD GAME OF HANGMAN AND VICTIM,
PERSECUTOR AND PERSECUTED,
HUNTER AND HUNTED—

FOOTSTEPS
WHICH TURN TIME RAVENOUS
EMBLAZONING THE HOUR WITH WOLVES
EXTINGUISHING THE FLIGHT IN THE FUGITIVE'S
BLOOD.

FOOTSTEPS
COUNTING TIME WITH SCREAMS, GROANS,
THE SEEPING OF BLOOD UNTIL IT CONGEALS,
HEAPING UP HOURS OF SWEATY DEATH—

STEPS OF HANGMEN
OVER THE STEPS OF VICTIMS,
WHAT BLACK MOON PULLED WITH SUCH TERROR
THE MINUTE—HAND IN EARTH'S ORBIT?

WHERE DOES YOUR NOTE SHRILL
IN THE MUSIC OF THE SPHERES?

NELLY SACHS

Death Camp Irene Klepfisz the chimney g'vat mayg wd der my smile When I peered through

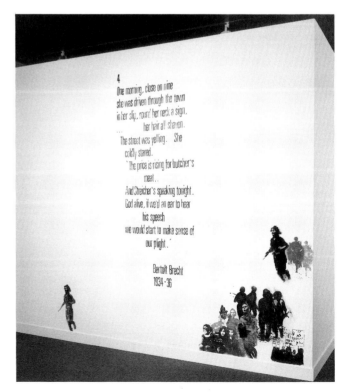

4
One morning, close on nine
she was driven through the town
in her slip, round' her neck a sign,
. . . her hair all shaven.
The street was yelling. She
coldly stared.
`The price is rising for butcher's
meat. . .
And Streicher's speaking tonight.
God alive, if we'd an ear to hear
his speech
we would start to make sense of
our plight.'

Bertolt Brecht
1934-36

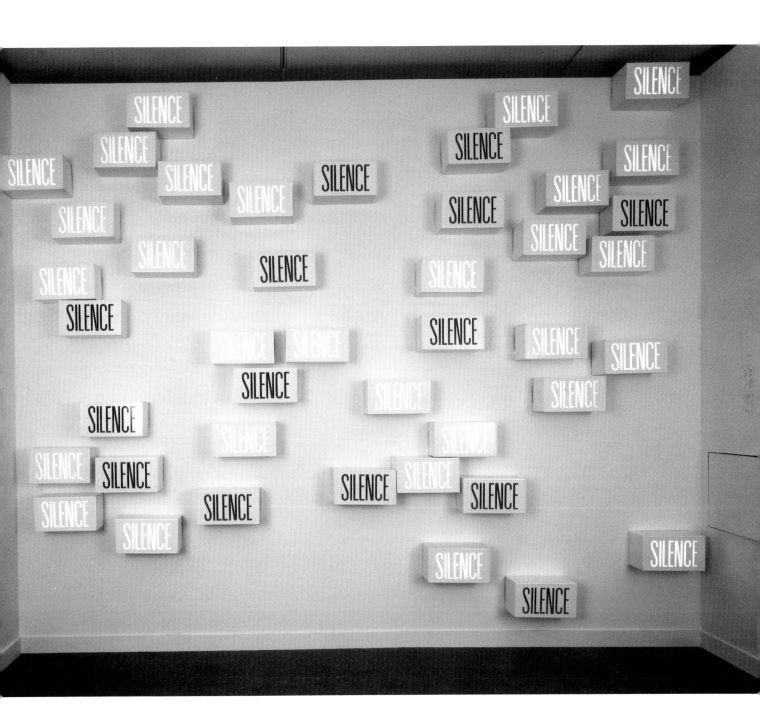

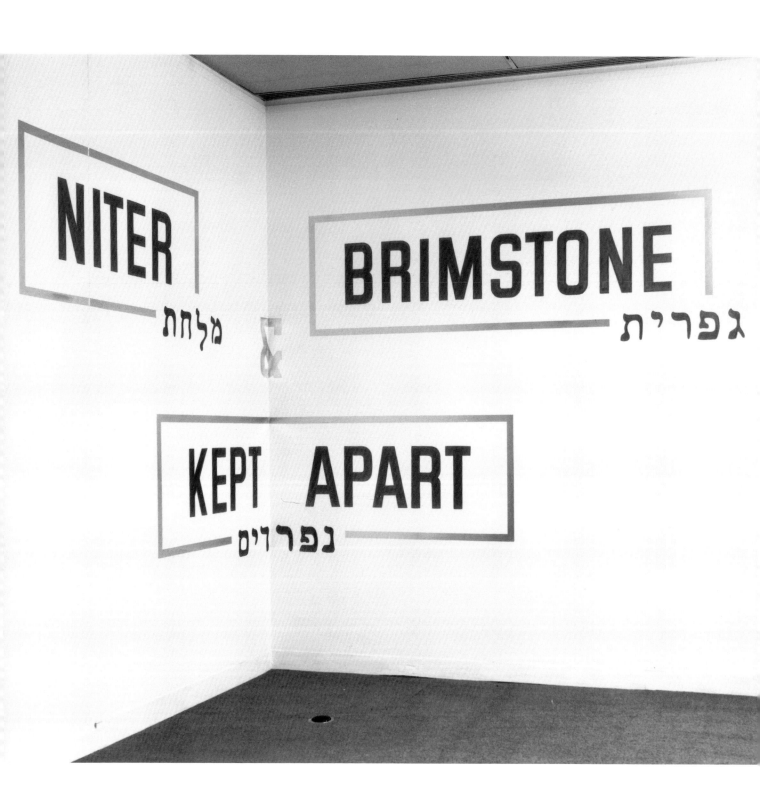

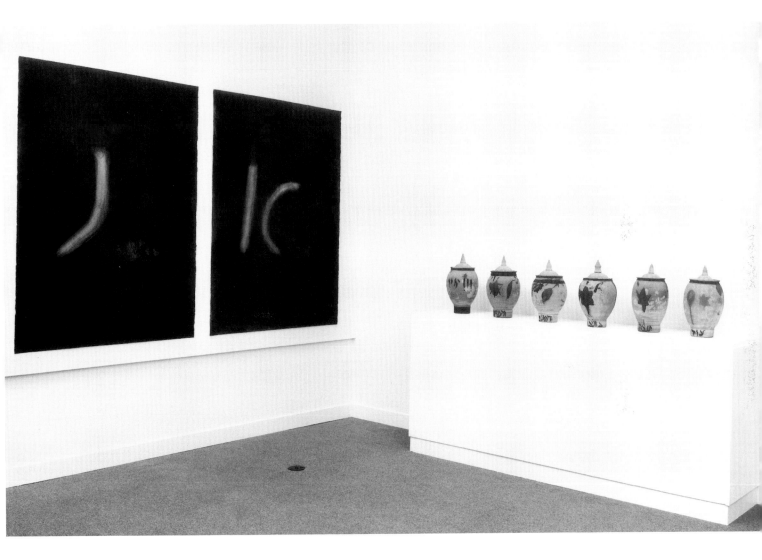

CHRISTIAN BOLTANSKI

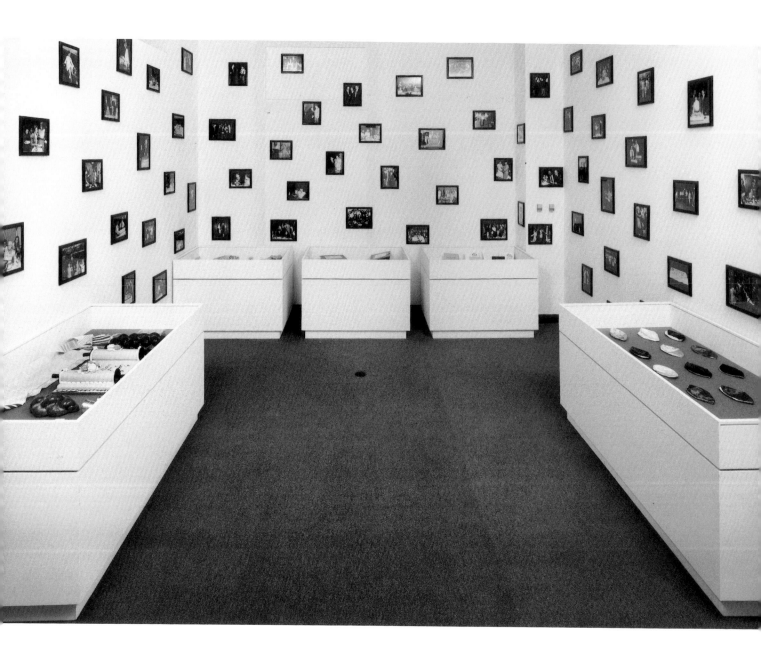

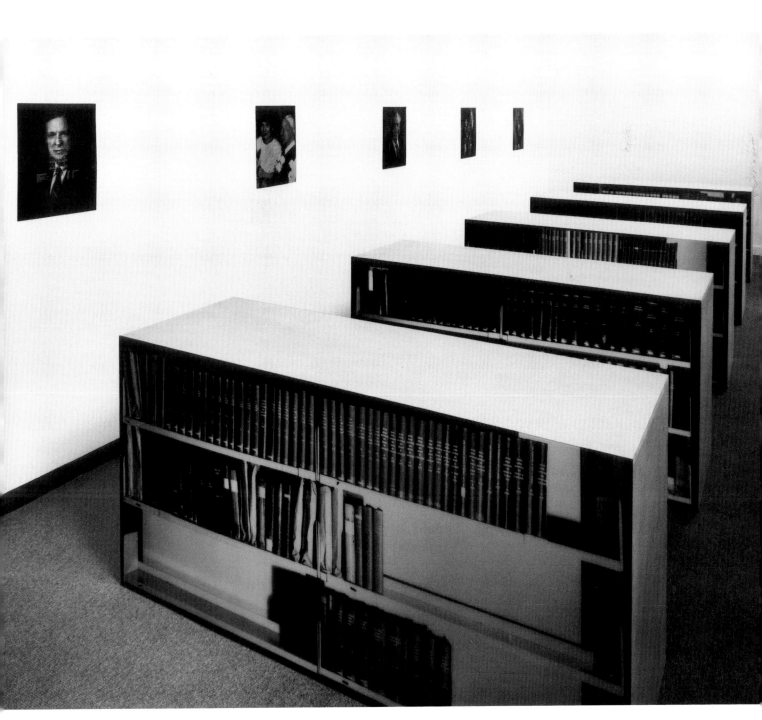

ELEANOR ANTIN

Born in New York
Lives in Del Mar, California

Education: City College of New York (BA, 1958); Tamara Daykarhanova School for the Stage, New York, 1955-57; The New School for Social Research, New York, 1956-59

Teaching Positions: Visual Arts Department, University of California at San Diego, 1975-present

Bibliography and Exhibition History 1970-92

Selected One-Artist Exhibitions 1970-92

1973 The Museum of Modern Art, New York: "100 Boots"

1978 Whitney Museum of American Art, New York, "The Ballerina"

1989 Artemisia, Chicago, "Photographic Works"

Selected Performances 1970-1992

1975 San Diego Museum of Art, and Palace of Fine Arts, San Francisco, *The Battle of the Bluffs* (performed internationally through 1982; also shown on Italian network television in the complete version in 1976)

1977 M.L. D'Arc Gallery, New York, and La Jolla Museum of Contemporary Art, California, *The Angel of Mercy* (catalogue; also performed 1981)

1980 Ronald Feldman Fine Arts, New York; and 80 Langton Street, San Francisco, *Recollections of My Life with Diaghilev* (performed through 1985)

1983 Ronald Feldman Fine Arts, New York, *El Desdichado (The Unlucky One)*

1986 LACE, Los Angeles; Intersection, San Francisco; and Lyceum Space, Horton Plaza, San Diego, *Help! I'm in Seattle* (performed through 1987)

Selected Films 1970-92

1986 *It Ain't the Ballet Russe!* (Fifth Annual California First Film Festival, La Jolla, California)

Ronald Feldman Fine Arts, New York, *Loves of a Ballerina*

1989 Whitney Museum of American Art, New York, "1989 Biennial Exhibition," *The Last Night of Rasputin* (a film with performance; also screened at additional locations)

1991 La Jolla Museum of Contemporary Art, California, *The Man Without a World* (also screened at additional locations)

Selected Group Exhibitions 1980-92

1980 The High Museum of Art, Atlanta, "Contemporary Art in Southern California" (catalogue)

1981 The New Museum of Contemporary Art, New York, "Alternatives in Retrospect" (catalogue)

Museum of Contemporary Art, Chicago, "California Performance" (video)

Contemporary Arts Museum, Houston, "Other Realities: Installations for Performance" (catalogue)

1982 Nelson Gallery-Atkins Museum of Art, Kansas City, Missouri, "Repeated Exposure: Photographic Imagery in the Print Media" (catalogue)

1983 The Museum of Modern Art, New York, "Video Art: A History (Part 2)"

Long Beach Museum of Art, California, "At Home" (catalogue)

1984 Hirshhorn Museum and Sculpture Garden, Smithsonian Institution, Washington, D.C., "Content: A Contemporary Focus, 1974-1984" (catalogue)

Institute of Contemporary Art, Boston, "Revising Romance: New Feminist Video" (catalogue; traveled)

Long Beach Museum of Art, California, "Video: A Retrospective, 1974-84" (catalogue)

1985 San Francisco Museum of Modern Art, "Signs of the Times: Some Recurring Motifs in Twentieth-Century Photography" (catalogue)

Independent Curators, Inc., New York, "From the Collection of Sol Lewitt" (catalogue; traveled)

1987 American Film Institute Video Festival, Los Angeles, "From the Archives of Modern Art" (catalogue; video)

International Center for Photography, New York, "Fabrications—Staged, Altered, and Appropriated Photographs" (catalogue; traveled)

1988 Whitney Museum of American Art, Downtown at Federal Reserve Plaza, New York, "Identity: Representations of the Self" (brochure)

1989 Münchner Kunstverein, Munich, "Konstruierte Fotographie (Constructed Realities)" (catalogue; traveled)

Cincinnati Art Museum, "Making Their Mark" (catalogue; traveled)

1990 The Museum of Modern Art, New York, "Myths" (video)

Selected Writings by the Artist 1980-92

Being Antinova. Los Angeles: Astro Artz, 1983.

Selected Bibliography

Brass, Kevin. "Modern Silent Movie Re-creates Genre of the 20's." *Los Angeles Times,* June 8, 1991.

Deak, Frantsek. "Eleanor Antin: Before the Revolution: Acting as Art Paradigm." *Images and Issues,* 4 (January-February 1984), pp. 20-24.

Glueck, Grace. "In a Roguish Gallery: One Aging Black Ballerina." *The New York Times,* May 12, 1989.

Hoberman, J. "It's Déjà Vu All Over Again." *Premiere* (July 1992).

Munro, Eleanor. *Originals: American Women Artists.* New York: Simon & Schuster, 1979.

Raven, Arlene. "Outsider-Artist: Eleanor Antin." *Profile,* 1 (July 1981), pp. 1-23 (issue devoted to Antin).

Sayre, Henry. *The Object of Performance: The American Avant-Garde Since 1970.* Chicago: University of Chicago Press, 1989.

■

CHRISTIAN BOLTANSKI

Born in Paris, 1944
Lives in Paris

Education: Self-taught

Bibliography and Exhibition History
For selected listings of one-artist and group exhibitions, writings by the artist, and bibliographic references through 1990, see:

Christian Boltanski: Lessons of Darkness. Exhibition catalogue. Chicago: Museum of Contemporary Art, 1988.

Reconstitution: Christian Boltanski. Exhibition catalogue. London: The Whitechapel Art Gallery; Eindhoven, The Netherlands: Stedelijk Van Abbemuseum; and Grenoble, France: Musée de Grenoble, 1990.

Selected One-Artist Exhibitions 1991-92

1991 Marian Goodman Gallery, New York, "The Dead Swiss"

Galerie Ghislaine Hussenot, Paris, "La réserve des suisses morts"

Kunsthalle Hamburg, "Inventar" (catalogue)

Lisson Gallery, London, "Conversation Pieces"

1992 Gallery Senda, Hiroshima

Selected Group Exhibitions 1991-92

1991 The Carnegie Museum of Art, Pittsburgh, "Carnegie International" (catalogue)

Art Gallery of Ontario, Toronto, "Individualities: 14 Contemporary Artists from France"

Spoleto Festival U.S.A., Charleston, South Carolina, "Places with a Past: New Site-Specific Art in Charleston" (catalogue)

1992 Musée d'Art Contemporain de Montréal, "Pour la suite du monde" (catalogue)

Centre d'Art Contemporain, Domaine de Kerguehennec, France, "La mémoire des formes"

Selected Writings by the Artist 1991-92

Archive of the Carnegie International, 1896-1991. Pittsburgh: The Carnegie Museum of Art; New York: Marian Goodman Gallery, 1991.

Inventory of Objects Belonging to a Young Woman of Charleston. Charleston, South Carolina: Spoleto Festival U.S.A., 1991.

Sans Souci. Frankfurt: Portikus; Cologne: Walther Konig.

Selected Bibliography 1991-92

Christian Boltanski: Livres. Ed. Jennifer Flay. Paris: Association Française d'Action Artistique, Ministère des Affaires Êtrangères; Cologne: Walther Konig; and Frankfurt: Portikus, 1991.

Metken, Gunter. *Christian Boltanski: Memento Mori und Schattenspiel.* Frankfurt: Museum für Moderne Kunst, 1991.

■

CLEGG & GUTTMANN

MICHAEL CLEGG
Born in Dublin, 1957
Lives in New York

Education: Youth Program of the Israel Museum, Jerusalem; Chelsea School of Art, London; School of Visual Arts, New York

Teaching Positions: Taught with Martin Guttmann at the Hamburg Hochschule für Bildende Kunst, 1990

MARTIN GUTTMANN
Born in Jerusalem, 1957
Lives in New York

Education: Youth Program of the Israel Museum, Jerusalem; The Hebrew University of Jerusalem, BA; Columbia University, MA, M. Phil., Ph.D.

Teaching Positions: Taught with Michael Clegg at the Hamburg Hochschule für Bildende Kunst, 1990; currently teaching at Stanford University, Palo Alto, California

Bibliography and Exhibition History

For selected listings of one-artist and group exhibitions and bibliographic references through 1988, see:

Clegg & Guttmann: Portraits de groupes de 1980 à 1989. Exhibition catalogue. Bordeaux, France: CAPC Musée d'Art Contemporain, 1989.

Clegg & Guttmann: Corporate Landscapes. Exhibition catalogue. Bremerhaven, Germany: Kunstverein Bremerhaven; Velbert, Germany: Städische Museum Schloss Hardenberg, 1989.

Selected One-Artist Exhibitions 1989-92

1989 Pierre Hubert, Geneva

Giorgio Persano, Turin

Galerie Peter Pakesch, Vienna

1990 Kabinett für Aktuelle Kunst, Bremerhaven, Germany, "A Model for a Free Standing Outdoor Library"

Akira Ikeda Gallery, Tokyo

Jay Gorney Modern Art, New York, "The Free Public Library"

Julie Sylvester, New York, "Two and Four"

Galleri Nordanstad-Skarstedt, Stockholm

1991 Grazer Kunstverein, Graz, Austria, "Die Offene Bibliothek"

The Power Plant, Toronto, "The Open Canadian Tool Shelter: A Model"

Galerie Christian Nagel, Cologne, "Printing and Framing"

1992 Kunstraum Daxer, Munich, "The Outdoor Exhibition Space: Munich—San Francisco"

Vienna Festival, "The Outdoor Exhibition Space, Janecek-Hof, Vienna"

P.S. 1, Long Island City, New York, "From the Index of Commissioned and Non-Commissioned Photographic Portraits: Gazes in a Direction Perpendicular to the Picture Plane, Placed in a Sequence According to Their Intensity, and Accompanied by Varying Postures and Hand-Arrangements"

Selected Group Exhibitions 1989-92

1989 National Museum of American Art, Smithsonian Institution, Washington, D.C., "The Photography of Invention: American Pictures of the 1980s" (catalogue; traveled)

Musée d'Art Contemporain de Montréal, "Tenir l'image à distance"

Arti et Amicitiae, Amsterdam, "Parallel Views" (catalogue)

Wiener Secession, Vienna, and Palais des Beaux-Arts, Brussels, "Wittgenstein: The Play of the Unsayable"

Whitney Museum of American Art, New York, "Image World: Art and Media Culture" (catalogue)

1990 Whitney Museum of American Art, Downtown at Federal Reserve Plaza, New York, "The (Un)Making of Nature"

Deste Foundation for Contemporary Art, Athens, "Artificial Nature" (catalogue)

Villa Arson, Nice, "Le désenchantement du monde" (catalogue)

Nippon Convention Center, Makuhari Messe International Exhibition Hall, Tokyo, "Pharmakon '90" (catalogue)

Independent Curators, Inc., New York, "Team Spirit" (catalogue; traveled)

Musée National d'Art Moderne, Centre Georges Pompidou, Paris, "Art et Publicité" (catalogue)

1991 Walter Gropius Bau, Berlin, "Metropolis" (catalogue)

Museo d'Arte Contemporanea, Turin, "Squardo di Medusa"

1992 Center for the Arts, Wesleyan University, Middletown, Connecticut, "Multiple Exposure: The Group Portrait in Photography"

CAPC Musée d'Art Contemporain de Bordeaux, France, "Perils et Colères"

Musée d'art Contemporain Pully, Lausanne, "Post Human" (traveled)

Museo del Folklore, Rome, "Molteplici Culture"

University Art Museum, University of California, Santa Barbara, "Knowledge: Aspects of Conceptual Art"

Selected Bibliography 1989-92

Clegg, Michael, and Martin Guttmann. "Cumulus from America." *Parkett*, 28 (Spring 1991), pp. 163-64.

Crow, Thomas. "Fragen an einen Kunsthistoriker." *Texte zur Kunst*, 1 (Fall 1990).

Durand, Regis. "Clegg & Guttmann: ou les relations extérieures de l'art." *Art Press*, 161 (September 1991), pp. 21-25.

Grundberg, Andy. "Clegg and Guttmann: `The Free Public Library.'" *New York Times*, March 23, 1990.

Lingner, Michael. "Metaphorische Selbstverwaltung." *Kunst Unterricht* (September 1991).

Mahoney, Robert. "Clegg and Guttmann's *The Free Public Library*." *Arts Magazine*, 64 (Summer 1990), pp. 92- 93.

Nesbitt, Lois E. "Clegg & Guttmann: Jay Gorney Modern Art." *Artforum*, 28 (Summer 1990), p. 164.

Tallman, Susan. "Get the Picture?" *Arts Magazine*, 64 (Summer 1990), pp. 15-16.

Wei, Lily. "On Nationality: 13 Artists." *Art in America*, 79 (September 1991), pp. 124-31.

MOSHE GERSHUNI

Born in Tel Aviv, 1936
Lives in Tel Aviv

Education: Avni Art Institute, Tel Aviv, 1960-64

Teaching Positions: Bezalel Academy of Art and Design, Jerusalem, 1972-77; State Art Teachers' Training College, Ramat HaSharon, 1978-present

Bibliography and Exhibition History

For selected listings of one-artist and group exhibitions and bibliographic references through mid-1992, see:

Positionen Israel. Exhibition catalogue. Zug, Switzerland: W. Asperger Gallery, 1992, pp. 58-60.

Selected Bibliography

Deecke, T., and I. Levi. *Moshe Gershuni.* Exhibition catalogue. Münster: Westfälische Kunstverein, 1983.

Breitberg-Semel, S. *Moshe Gershuni: Malereien auf Papier.* Exhibition catalogue. Munich: Galerie Hasenclever, 1987.

Levi, I., and Y. Zaloma. *Moshe Gershuni, 1980-1986.* Exhibition catalogue. Jerusalem: The Israel Museum, 1986.

∎

ILYA KABAKOV

Born in Dnepropetrovsk, the Ukraine, 1933
Lives in Europe and New York

Education: Moscow Secondary School of the Arts (MSCHS), 1945-52; W. Surikov Art Institute of Moscow, 1951-57

Teaching Positions: Staatliche Hochschule für Bildende Künste, Städelschule, Frankfurt, 1992; Royal Danish Academy of Fine Art, Copenhagen, 1992

Bibliography and Exhibition History

For selected listings of one-artist and group exhibitions and bibliographic references through 1989, see:

Between Spring and Summer: Soviet Conceptual Art in the Era of Late Communism. Exhibition catalogue. Boston: Institute of Contemporary Art; Tacoma, Washington: Tacoma Art Museum, 1990.

Storr, Robert. *Dislocations.* Exhibition catalogue. New York: The Museum of Modern Art, 1991.

Selected One-Artist Exhibitions 1990-92

1990 Neue Galerie-Museum Ludwig, Aachen, "The Ship: An Installation"

Orchard Gallery, Derry, Ireland, "Four Cities Project" (catalogue)

Kassler Kunstverein, Kassel, "Seven Exhibitions of a Painting" (catalogue)

Hirshhorn Museum and Sculpture Garden, Smithsonian Institution, Washington, D.C., "Selections from Ten Characters" (catalogue)

Fred Hoffman Gallery, Santa Monica, California, "The Rope of Life and Other Installations" (catalogue)

Ronald Feldman Fine Arts, New York, "He Lost His Mind, Undressed, Ran Away Naked" (catalogue, including "Album of My Mother")

1991 Sezon Museum of Modern Art, Nagano, Japan, "Ilya Kabakov"

Galerie Peter Pakesch, Vienna, "The Targets"

Werwerka and Weiss Galerie, Berlin, "My Motherland/The Flies" (catalogue)

1992 Krannert Art Museum and Kinkead Pavillion, University of Illinois at Urbana-Champaign: "Ilya Kabakov"

Kölnischer Kunstverein, Cologne, "Ilya Kabakov"

Galerie Dina Vierny, Paris, "Ilya Kabakov"

Selected Group Exhibitions 1990-92

1990 Museo d'Arte Contemporanea, Prato, "Soviet Art" (catalogue)·

Eighth Biennale of Sydney, "The Readymade Boomerang: Certain Relations in 20th-Century Art" (catalogue)

Aldrich Museum of Contemporary Art, Ridgefield, Connecticut, "Adaptation and Negation of Socialist Realism" (catalogue)

Tacoma Art Museum, Washington, "Between Spring and Summer: Soviet Conceptual Art in the Era of Late Communism" (catalogue, traveled)

Alpha Cubic Gallery, Tokyo, "Soviet Contemporary Art 1990" (catalogue)

Daadgalerie, Berlin, "At Last, Freedom" (public art exhibition; catalogue)

Stedelijk Museum, Amsterdam, "In the U.S.S.R. and Beyond" (catalogue)

Columbus Museum of Art, Ohio, "The Quest for Self-Expression: Painting in Moscow and Leningrad 1965-1990" (catalogue; traveled)

Seoul Art Festival, "Works on Hanji Paper" (catalogue)

The New Museum of Contemporary Art, New York, "Rhetorical Image" (catalogue)

1991 Kunsthalle Düsseldorf, "Soviet Art Around 1990" (catalogue; traveled)

Night Lines (exhibition of outdoor sites sponsored by Centraal Museum, Utrecht)

Centraal Museum, Utrecht, "Words Without Thoughts Never to Heaven Go" (catalogue)

Auditorio de Galicia, Santiago de Compostela, Spain, "Contemporary Soviet Art" (catalogue)

Setagaya Museum, Tokyo, "Soviet Contemporary Art: From Thaw to Perestroika" (catalogue)

Cetinje, Yugoslavia, "Biennial of Cetinje"

Kunstverein Hannover, "Kunst, Europa: Sowjetunion"

Rooseum Center for Contemporary Art, Malmö, Sweden, "TRANS/Mission" (catalogue)

Institute of Contemporary Art, University of Pennsylvania, Philadelphia, "Devil on the Stairs: Looking Back on the Eighties" (catalogue; traveled)

The Museum of Modern Art, New York, "Dislocations" (catalogue)

The Carnegie Museum of Art, Pittsburgh, "1991 Carnegie International" (catalogue)

Grosse Orangerie of Charlottenburg Palace, Berlin, "Weightless"

Stedelijk Museum, Amsterdam, "Wanderlieder"

Jane Vorhees Zimmerli Art Museum, Rutgers University, New Brunswick, New Jersey, "New Directions"

Ateliers Municipaux d'Artistes, Marseilles, "Ilya Kabakov/Yuri Kuper: 52 Entretiens dans la cuisine communitaire" (catalogue; traveled)

The Power Plant, Toronto, "Ilya Kabakov/John Scott"

1992 Groninger Museum, Groningen, The Netherlands, "Seven Artists from Russia"

"Documenta 9," Kassel, Germany (catalogue)

Villa Campolieto Ercolano, Italy, "A Mosca...A Mosca" (catalogue; traveled)

Selected Writings by the Artist 1990-92

"The Art of the One Who Flees: Dialogues About Fear, Sacred Whiteness and Soviet Garbage" (dialogue with Boris Groys). Munich and Vienna: Carl Hanser Verlag, 1991.

Ilya Kabakov: Life of Flies. Cologne: Kölnischer Kunstverein, 1991.

Selected Bibliography 1990-92

Cembalest, Robin. "The Man Who Flew into Space." *Art News,* 89 (May 1990), pp. 176-81.

Heartney, Eleanor. "Nowhere to Fly." *Art in America,* 78 (March 1990), pp. 176-77.

_____. "Post-Utopian Blues." *Sculpture,* 9 (May-June 1990), pp. 62-67.

Jolles, Claudia. "Ilya Kabakov—Die Kraft der Erinnerung." *Kunst Bulletin,* 3 (March-April, 1992), pp. 16-23.

Solomon, Andrew. "Artist of the Soviet Wreckage." *The New York Times Magazine,* September 20, 1992.

Tupitsyn, Victor. "The Communal Kitchen: A Conversation with Ilya Kabakov." *Arts Magazine,* 66 (October 1991), pp. 48-55.

■

NANCY SPERO
Born in Cleveland, 1926
Lives in New York

Education: The School of the Art Institute of Chicago (BFA, 1949);
Atelier André L'Hote, Paris, 1949-50;
École des Beaux-Arts, Paris, 1949-50

Teaching Positions: Milton Avery Professor of Art/Visiting Artist, Bard College, Annandale-on-Hudson, New York, 1990; Visiting Artist/Professor, Internationale Sommerakademie für Bildende Kunst, Salzburg, 1992

Bibliography and Exhibition History
For selected listings of one-artist and group exhibitions and bibliographic references through 1990, see:

Nancy Spero: (retrospective). Exhibition catalogue. London: Institute of Contemporary Arts, 1987.

Nancy Spero: Works Since 1950 (retrospective). Exhibition catalogue. Syracuse, New York: Everson Museum of Art, 1987.

Nancy Spero: Bilder 1958 bis 1990 (retrospective). Exhibition catalogue. Berlin: Haus am Waldsee; Bonn: Bonner Kunstverein, 1990.

Selected One-Artist Exhibitions 1991-92

1991 Josh Baer Gallery, New York

Galerie Barbara Gross, Munich

Glyptothek am Konigsplatz, Munich, "Nancy Spero in der Glyptothek: Arbeiten auf Papier 1981-1991" (catalogue)

Galleria Stefania Miscetti, Rome, "Sky Goddess, Egyptian Acrobat," "Torture of Women," and "Cabaret" (catalogue)

Salzburger Kunstverein, Künstlerhaus Salzburg, "Works on Paper 1981-1991"

Galerie Jürgen Becker, Hamburg

Galerie Raymond Bollag, Zurich, "Works on Paper"

Galerie Gebrüder Lehmann, Dresden

UWM Museum of Art, University of Wisconsin, Madison, "Nancy Spero and Leon Golub: A Commitment to the Human Spirit" (catalogue)

1992 Ulmer Museum, Ulm, "Nancy Spero: Woman Breathing" (catalogue)

Terrain Gallery, San Francisco, "Hieroglyphs"

Selected Group Exhibitions/Wall Printing Installations 1991

1991 Circulo de Bellas Artes, Madrid, "El Sueño Imperativo" (catalogue)

Harold Washington Library Center, Chicago, "To Soar III"

Institute of Contemporary Art, University of Pennsylvania, Philadelphia, "Devil on the Stairs: Looking Back on the Eighties" (catalogue; traveled)

Von der Heydt-Museum, Wuppertal, Germany, "Buchstablich, Bild und Wort in der Kunst heute" (catalogue)

Group Exhibitions 1991-92

Irish Museum of Modern Art, Dublin, "Inheritance and Transformation"

Setagaya Museum, Tokyo, "Beyond the Frame: American Art 1960-1990" (catalogue; traveled)

Circulo degli Artisti, Rome, "Artae"

El Centro Cultural/Arte Contemporaneo, Polanco, Mexico: "El sueño de Egipto: la influencia del arte (catalogue)

The National Museum of Women in the Arts, Washington, D.C., "Presswork: The Art of Women Printmakers" (catalogue; traveled)

Dum Umèní Mesta Brna, Brno, Czecho-slovakia, "Detente" (catalogue; traveled)

The Print Club, Philadelphia, "Crossing Over, Changing Places"

The Alternative Museum, New York, "Artists of Conscience: 16 Years of Social and Political Commentary" (catalogue)

1992 The Museum of Modern Art, New York, "Allegories of Modernism: Contemporary Drawing" (catalogue)

The School of the Art Institute of Chicago, "From America's Studio: Drawing New Conclusions"

The Maryland Institute, College of Art, Baltimore, "Beyond Glory"

Museum of Architecture, Warsaw, "International Drawing Triennale"

Group Exhibitions/Wall Printing Installations 1993

1993 Whitney Museum of American Art, New York, "1993 Biennial Exhibition" (catalogue)

Selected Bibliography 1991-92

Board, Marilyn Lincoln. "To The Revolution: Nancy Spero's Art in the Sight of Social Transformation in the Context of French Feminist Theory." *Selected Essays in the International Conference on Representing Revolution*, West Georgia College, 1991, pp. 152-62.

Bonetti, David. "Hieroglyphs Better Than Words." *San Francisco Examiner*, March 20, 1992.

Faust, Gretchen. "New York in Review." *Arts Magazine*, 65 (May 1991), p. 97.

Francia, Luisa. "Ich bin kein Bestseller." *Die Tageszeitung*, May 15, 1991.

Frazer, Kathleen. "Letter from Rome: H. D., Spero and the Reconstruction of Gender." *M/e/a/n/i/n/g*, 10 (November 1991), pp. 40-43.

Hess, Elizabeth. "Collateral Damage." *The Village Voice*, March 12, 1991.

Holert, Tom. "Kunst Weiblichkeit im Widerstand." *Vogue* [German edition], (April 1992).

Lang, Jörg. "Nancy Spero stempelt Brecht." *Wuppertaler Rundschau*, May 24, 1991.

Mania, Patrizia. "Nancy Spero: Galleria Stefania Miscetti." *Tema Celeste*, 32-33 (Autumn 1991), p. 122.

Shottenkirk, Dena. "Nancy Spero: Josh Baer Gallery." *Artforum*, 29 (May 1991), p. 143.

Smith, Roberta. "Nancy Spero." *The New York Times*, March 8, 1991.

Vogel, Thomas. "Spurensuche nach den Frauen." *Neu-Ulmer Zeitung*, April 14, 1992.

Withers, Josephine. "Nancy Spero's American-born *Sheela-na-gig*." *Feminist Studies*, 17 (Spring 1991), pp. 51-56.

Wye, Pamela. "Freedom of Movement: Nancy Spero's Site Paintings." *Arts Magazine*, 65 (October 1990), pp. 54-58.

■

BARBARA STEINMAN
Born in Montreal, 1950
Lives in Montreal

Education: McGill University, Montreal, 1971; Concordia University, Montreal, 1974

Bibliography and Exhibition History

For selected listings of one-artist and group exhibitions and bibliographic references through 1991, see:

Uncertain Monuments. Exhibition catalogue. Regina, Saskatchewan: Mackenzie Art Gallery, 1992.

Selected One-Artist Exhibitions 1989-92

1989 Artists Space, New York, "Project: Barbara Steinman" (video installation)

Galerie René Blouin, Montreal (also 1991, 1992)

1990 Mandeville Gallery, La Jolla, California (video installation)

The Museum of Modern Art, New York (video installation)

1991 The Banff Centre for the Arts, Alberta, "Promissory Notes" (catalogue: *Between Views*)

Selected Group Exhibitions 1989-92

1989 The National Gallery of Canada, Ottawa, "Canadian Biennial of Contemporary Art" (catalogue)

Kölnischer Kunstverein, Cologne, and Kongresshalle Berlin, Berlin, "Video-Skulptur Retrospektiv und Aktuell: 1963-1989" (catalogue)

1990 Centro de Arte Reina Sofía, Madrid, "Bienal de la imagen en movimiento '90" (catalogue)

The New Museum of Contemporary Art, New York, "Rhetorical Image" (catalogue)

International Sculpture Center, Washington, D.C., "International Sculpture '90"

Eighth Biennale of Sydney, "The Readymade Boomerang: Certain Relations in 20th-Century Art" (catalogue)

1991 Musée du Québec, "Les artistes du Québec et la scène internationale"

Spoleto Festival U.S.A., Charleston, South Carolina, "Places with a Past: New Site-Specific Art in Charleston" (catalogue)

1992 Musée d'Art Contemporain de Montréal, "Pour la suite du monde" (catalogue)

Cadran Solaire Art Contemporain, Chapelle de l'Hôtel Dieu, Troyes, France, "L'imperceptible trajet" (catalogue)

Selected Bibliography

Ferguson, Bruce. "The Art of Memory—Barbara Steinman." *Vanguard*, 18 (Summer 1989), pp. 10-15.

_____. "Places with a Past: New Site-Specific Art in Charleston." *Canadian Art*, 8 (Winter 1991), pp. 68-70.

Gumpert, Lynn. "Cumulus from America." *Parkett*, 29 (Fall 1991), pp. 163-69.

Marker, Josef. "Barbara Steinman: Poetry and Politics Compounded." *In Site* (Summer 1991), p. 7.

McKay, Gillian. "Barbara Steinman." *Canadian Art*, 9 (Fall 1992), pp. 38-43.

Shottenkirk, Dena. "Barbara Steinman." *Artforum*, 29 (November 1990), p. 170.

■

LAWRENCE WEINER
Born in New York, 1942
Lives in New York and Amsterdam

Education: Self-taught

Bibliography and Exhibition History

For selected listings of one-artist and group exhibitions and bibliographic references through 1988, see:

Lawrence Weiner: Works from the Beginning of the Sixties Towards the End of the Eighties. Exhibition catalogue. Amsterdam: Stedelijk Museum, 1988.

Selected One-Artist Exhibitions 1989-92

1989 Marian Goodman Gallery, New York, "Here, There and Everywhere" (also 1990)

Galerie Brigitte March, Stuttgart (catalogue)

Galerie Ascan Crone, Hamburg (also 1991)

Portikus, Frankfurt, "Books Do Furnish a Room: Ausstellung Nr. 17/Bücher Lawrence Weiner" (catalogue)

L'École Supérieure d'Art Visuel, Geneva, "Posters Hanging in European Collections" (catalogue)

Stuart Regen Gallery, Los Angeles, "Assuming the Position" (also 1991, 1992)

L'École Régionale des Beaux-Arts de Dunkerque, France, "Stones + Stones 2+2=4" (catalogue)

1990 Le Nouveau Musée Villeurbanne, Villeurbanne, France, "Learn to Read Art—Livres et Affiches"

Galerij Foksal, Warsaw, "On One Side of the Same Water" (catalogue)

Joods Historisch Museum, Amsterdam, "Licht = (Licht)" (catalogue)

Hirshhorn Museum and Sculpture Garden, Smithsonian Institution, Washington, D.C., "Works: With the Passage of Time" (catalogue)

1991 Leo Castelli Gallery, New York, "Dropped Stones"

Art and Project, Amsterdam, "Thrown Someplace/Ergens Neergegooid" (catalogue)

Institute of Contemporary Arts, London, "Spheres of Influence" (catalogue)

DIA Center for the Arts, New York, "Displacement" (catalogue)

Palais des Beaux-Arts, Brussels, "Livres and Boeken" (catalogue: *You Can Tell A Book By Its Cover*)

1992 San Francisco Museum of Modern Art, "Chains Wrapped Around One Thing and Another Broken One by One with the Passage of Time" (catalogue)

Galerie Nationale du Jeu de Paume, Paris, "Lawrence Weiner—Films & Videos"

École Supérieure d'Art Visuel, Geneva, "Show & Tell & Then—The Films And Videos of Lawrence Weiner" (catalogue)

Museum Boymans-van Beuningen, Rotterdam, "& Onward &"

CAPC Musée d'Art Contemporain, Bordeaux, France, "Quelques Choses..."

Selected Group Exhibitions 1989-92

1989 Grand-Palais, Paris, "Saga 89" (3rd International Exhibition of Prints and Editions of Art; also 1990, 1991, 1992)

Musée National d'Art Moderne, Centre Georges Pompidou, and La Grande Halle, La Villette, Paris, "Magiciens de la terre" (catalogue)

Capitou, France, "Fondation Daniel Templon: L'exposition inaugurale"

Museum Haus Esters, Krefeld, Germany, "Skulpturen für Krefeld I"

Museum van Hedendaagse Kunst, Antwerp, "Gran Pavese: The Flag Project"

Musée d'Art Moderne de la Ville de Paris, "L'art conceptual: une perspective"

1990 Eighth Biennale of Sydney, "The Readymade Boomerang: Certain Relations in 20th-Century Art" (catalogue)

Centre International d'Art Contemporain de Montréal, "Savoir Vivre, Savoir Faire, Savoir Être"

Haags Gemeentemuseum, The Hague, The Netherlands, "Hommage aan Vincent van Gogh"

The New Museum of Contemporary Art, New York, "Rhetorical Image" (catalogue)

Art Gallery of Ontario, Toronto, "Inquiries: Language in Art" (traveled)

Milwaukee Art Museum, "Word as Image: American Art 1960—1990" (traveled)

1991 Irish Museum of Modern Art, Dublin, "Inheritance and Transformation"

Weiner Festwochen, Vienna (catalogue)

Sprengel Museum, Hannover, "Aussenraum—Innenstadt"

Institute of Contemporary Art, Amsterdam, "Jorge Luis Borges"

Stedelijk Museum, Amsterdam, "Wanderlieder"

1992 Altonaer Museum, Hamburg, "Die Künstlerpostkarte"

Museo d'Arte Moderna, Bolzano, Italy, "Heinz Gappmayr, Maurizio Nannucci, Lawrence Weiner: Denkraume/Spazi del pensiero"

Château de Jau, Cases de Pène, Musée d'Art Moderne, Collioure, France, "Exposition Sentimentale"

Selected Artist Books 1989-92

All Fall Down. Bolzano: Museo d'Arte Moderna, 1992.

Art & Project/Lawrence Weiner. Thrown Someplace/Ergens Neergegooid. Amsterdam: Art & Project, 1991.

In the Crack of the Dawn. Lucerne and Brussels: Galeries Mai 36 and Yves Gevaert, 1991.

La Marelle/Pie in the Sky. Villeurbanne, France: Le Nouveau Musée, 1990.

Ta Sama Woda/The Same Water. Warsaw: Biblioteka Galerij Foksal, 1990.

Just Another Thing Taken & Changed (A Wood) (A Stone). Antwerp and Brussels: Galeries Micheline Szwajcer and Yves Gevaert, 1989.

Plowman's Lunch Comix. Rotterdam: Uitgeverij Bebert, 1989.

Selected Bibliography 1989-92

Batchelor, David. "I Am Not Content." *Artscribe International,* 74 (March-April 1989), pp. 50-53.

Gardner, Colin. "The Space Between Words: Lawrence Weiner." *Artforum,* 29 (November 1990), pp. 156-60.

Leffingwell, Edward, and Lawrence Weiner. "When You Offer Stones You Get Stones." *Parkett,* 30 (Winter 1991), pp. 6-19.

Mahoney, Robert. "Une contrée inexplorée: le Logos dans l'espace littéral [Robert Barry/Lawrence Weiner]." *Artstudio,* 15 (Winter 1989).

Poinsot, Jean-Marc. "De nombreux objets colorés placés côté à côté pour former une rangée de nombreux objets colorés." *Artstudio,* 15 (Winter 1989).

_____. "Lawrence Weiner: `Je n'ai pas de conversation avec le ciel.'" *Beaux-Arts Magazine,* 65 (February 1989).

Schwarz, Dieter. "Utiliser le langage, utiliser l'art: le travail de Lawrence Weiner." *Cahiers du Musée National d'Art Moderne,* 33 (Autumn 1990).

■

CREDITS

PHOTOGRAPHY

page 24: courtesy
Milestone Film and
Video

page 25: Becky Cohen

page 29: Clegg &
Guttmann

page 30: Heiman Michal

page 31: *Green Pastures*:
Meidad Suchowolski

page 32: John Aquino

page 33: John Back

page 34: Abe Frajndilch
NYC Summer 1990

page 35: Antje Zeis-Loi

page 36: Bernard Bohm

page 37: Louis Lussier

page 38: Chris Felver,
© 1986

page 39: John Back

The Jewish Museum
installations,
pages 41 - 49:
Patricia Layman
Bazelon

Nancy Spero would like to thank Samm Kunce, Shari Zolla, Ingrid Abrash, David Clement and Kay Pallister. Thanks to Irene Sosa for documenting the installation, and to Aviva Weintraub for her research.

Eleanor Antin would like to thank her creative and technical crew:
David Thayer, who so precisely understood and helped concretize her intentions; Richard Wargo and Lynn Burnstan, her film crew once again; Josef Kucera, sound engineer; Leo Benavidez, computer programmer; Alison Tatlock, Kurt Reichert, Gilliam Jones, Brian Welsh, actors; Marcia Goodman, rehearsal coach; Sabato Fiorello, set dresser; Mishe Wilcox, costumes; Laura Andrews, make-up; Mark Maltby, construction; and Pam Whidden, her personal assistant.

T·H·E
JEWISH
MUSEUM

1109 Fifth Avenue

New York, NY 10128